IMAGES
of America

MANHATTAN BEACH
PIER

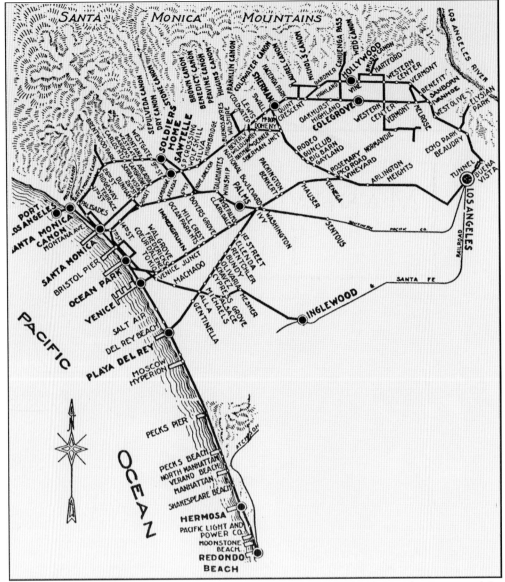

By 1909, the coastline of the Santa Monica Bay saw piers and wharfs stretching out into the Pacific Ocean. The Port of Los Angeles, fondly named the "Long Wharf," received hundreds of both sailing ships and steamers. Most of the smaller piers were fishing locations, and others were recreation centers. The Los Angeles Pacific Company (the "Red Car") provided transportation to them all.

IMAGES
of America

MANHATTAN BEACH
PIER

Jan Dennis

Published by Arcadia Publishing
Charleston SC, Chicago IL, Portsmouth NH, San Francisco CA

Printed in the United States of America

Library of Congress Catalog Card Number: 2005926076

For all general information contact Arcadia Publishing at:
Telephone 843-853-2070
Fax 843-853-0044
E-mail sales@arcadiapublishing.com
For customer service and orders:
Toll-Free 1-888-313-2665

Visit us on the internet at http://www.arcadiapublishing.com

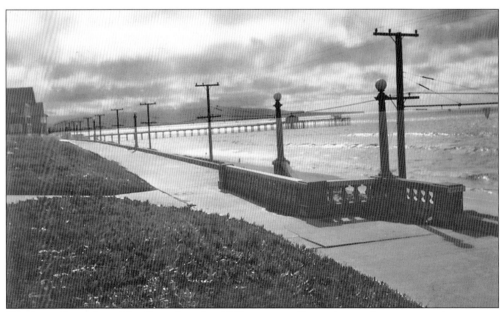

While strolling along The Strand in the 1930s, one could see the newly constructed extension to the pier with the Palos Verdes hills in the background.

CONTENTS

ACKNOWLEDGMENTS

An indebted thank you goes to Sharri Hogan, who shared with me many wonderful photographs of the pier and who inspired me to write this book. A pictorial book of this kind takes many hours of compiling, organizing, and researching from many sources. My greatest appreciation goes to John Scott, who provided the technical preparation of these images, adding clarity and strength to visuals that might not otherwise have been usable. John has lent his computer skills to three previous books: *Manhattan Beach, California*; *Manhattan Beach Police Department*; and *Shadows on the Dunes*. Without his dedication to this book, *Manhattan Beach Pier* would not have been possible.

A special thank you goes to three people who provided essential photographs: Mrs. Liza Tamura, city clerk of Manhattan Beach; Michael Daly, city manager of Jackson, California; and Chris Miller, photographer for *The Beach Reporter*.

This acknowledgment would not be complete without expressing my gratitude to Charlie Saikley, "Mr. Volleyball," for generously providing invaluable information on the history of the game.

Lastly, but not least, I am indebted to Mrs. Esther Besbris for her editor's eye and long-standing encouragement with these historical volumes.

Photograph, book, and newspaper credits go to the following: Martha Andreani, Manhattan Beach Chamber of Commerce, Mary Pat Dorr, *A Walk Beside the Sea* by Jan Dennis, Downs Family, *Port Los Angeles* by Ernest Marquez, Charlie Saikley, *Sands of Time* by Art Couvillon, Julia Tedesco, *Easy Reader*, Chandler P. Ward, *The Beach Reporter*, City of Manhattan Beach, and *The Waterfront of Manhattan Beach* by Linda McCallister.

Though I have attempted to recognize all of those who supplied material to this project, some may have been inadvertently missed. Therefore, to each and every one of you, I extend my profound appreciation.

—Jan Dennis

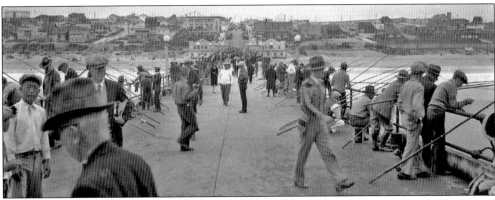

A typical sunny day was an irrresistible invitation to fish off the Manhattan Beach Pier.

INTRODUCTION

Manhattan Beach Pier is not only the story of a historic landmark, but also an in-depth record of the surrounding area and the people whose lives found enjoyment in its shadows. With clear skies, dry air, little or no humidity, comfortable nights, and prevailing sea breezes, it is no wonder this site was seen as ideal for recreational living.

In 1897, the Potencia Townsite Company purchased the Manhattan Beach waterfront, which had become the downtown site as well. The company wanted to create a seaside resort with bathing, boating, and fishing facilities along with the construction of a pleasure pier. John Shirley Ward, president of the Potencia Company, fell under the spell of an engineer/inventor who sought an ocean-based location for what he called a "wave motor." Observing the wave action on the underdeveloped beach, the inventor was satisfied with the Potencia venue. The purpose of his invention was to produce cheap electricity, which did serve to power for a short time, to the lighting system along the boardwalk (later known as The Strand). Its major drawback ultimately caused it to be discarded, as the "Wave Machine" could produce electricity only when the surf was at the highest.

In 1901, Ward made arrangements for a siding on the Santa Fe rail line on the east side of what is now the Metlox property. Providing a landing for the supplies, machinery and equipment brought in for the construction of the pier. The west end of the boulevard (then named Center Street) saw the birth of Manhattan Beach's first pier referred to as "Old Iron Pier." Fashioned from railroad ties and timbers bound together, it supported a 900-foot wooden deck on wooden pilings pounded into the sand. The pier quickly became the focal point for many of the town's activities. A decade later, unable to withstand the turbulent winter storm of 1913–1914, it met its demise.

During this early period, several piers had made their appearance in the Santa Monica Bay. Manhattan Beach's pier was not the oldest. The City of Santa Monica had completed a wharf by May of 1875, measuring 1,740 feet long and 80 feet wide at its ocean end. By July of that year, two steamships from San Francisco brought prospective buyers to the town for a land auction.

Redondo Beach, located south of Manhattan Beach within the Santa Monica Bay, also preceded Manhattan's pier. In 1888, they constructed Wharf No. 1 and by 1895, a second wharf was built at what is today's Veteran's Park. Based on the discovery of a unique geological submarine valley running a half mile offshore of Redondo, a port for handling more than half of Los Angeles's cargo shipping was considered. Though it never materialized, many officials in the area envisioned Redondo as a deep-water harbor for the entire city of Los Angeles.

In 1914, Manhattan Beach set in motion plans to pass a bond for the purpose of replacing their destroyed pier. By 1916, after much discussion and compromise, a bond was approved by the voters. However, it would take until October 1917 before a contract would be awarded to engineer George W. Harding. After many challenging years during World War I, the new pier was opened on July 5, 1920. Other amenities opened in 1922, including a pavilion at the end of the pier and a bathhouse beneath the pier. A designer by the name of A. L. Harris was able to see his unique concept for a round-ended concrete pier completed before his passing in August 1922.

For the past 85 years, the concrete Municipal Pier has stood as an icon for the city of Manhattan Beach. Built not only for the residents of the town to enjoy, the structure has hosted thousands

of visitors who came to the shore-lined community. Since that dedication in 1920, the pier's distinctive profile has been photographed, rendered by artists' brushes, and appeared on everything from campaign posters to city notepaper. Traveling through other countries, one frequently sees former visitors to Manhattan Beach wearing T-shirts displaying the identifying pier. As one person remarked, "It's your trademark—the place to go!"

This journey through the years of development of Manhattan Beach's historic landmark not only highlights the recreational activities, the special events, and the attendance of dignitaries and celebrities, but illustrates how a small community grew because of a pier's widespread popularity. That attraction still exists as does the pride and protection its citizens evidence for their precious symbol.

Prior to the real estate boom of the 1880s, the Santa Monica Land Company brought prospective buyers to public auction from San Francisco by way of steamship. The town of Santa Monica had the only harbor in the bay. Note the lack of a pier or wharf in San Pedro Bay at this point in history.

One

BEGINNINGS

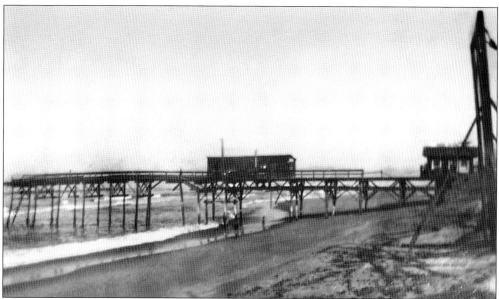

Legend has it that during the Civil War, Colonel B. Duncan built the first pier within the boundaries of Manhattan Beach and used it to bring opium ashore. This has never been verified. What is known is that Duncan constructed property that extended down to the water's edge, but still there was no evidence of a pier. More can be read about Colonel Duncan in *A Walk Beside the Sea*, also by Jan Dennis. John Shirley Ward, a Pasadena resident, was president of the Potencia Townsite Company, incorporated in 1897. In that same year, the time tables of the Santa Fe Railroad indicated the name of the area as Potencia. Anticipating future growth, this Spanish word meaning potential strength was aptly applied. Completed in 1901, the first recorded narrow wooden deck pier, built at its present location, was a unique construction employing iron crisscrossed railroad ties supported by three pilings pounded into the sandy shore. At this time, the area of the beachfront at this time was owned by the Potencia Townsite Company, who was responsible to a degree for the development of a wave machine located beneath the pier that was designed to transfer the power of the crashing waves to an electrical generator. The system supplied electricity to The Strand but worked only when there was heavy wave action.

Shirley Christopher Ward (1861–1929) was the son of John Shirley Ward. The Ward family owned property on The Strand for many years.

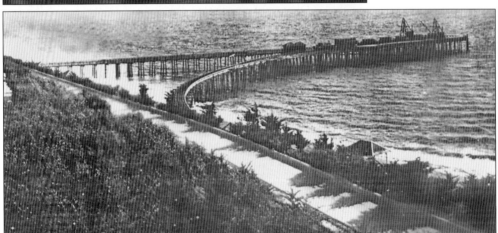

There was a much more progressive waterfront growth in neighboring Redondo Beach as the area was in contention to become the harbor for the City of Los Angeles. Three wharfs had already been built—the first one in 1888, the second in 1895, and the third one in 1903. The advantage of the site would afford ships to unload their cargoes directly onto the wharfs thus saving time and money. Ultimately, it was the decision of the U.S. Corps of Engineers that San Pedro Bay to the southeast would become the Los Angeles Harbor.

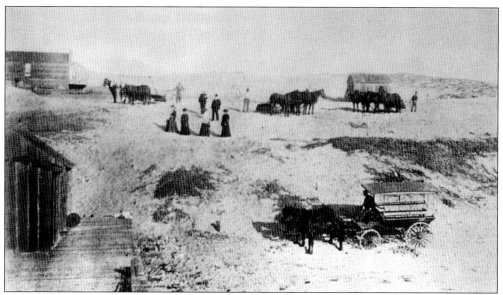

In September 1901, John A. Merrill and Associates acquired the beachfront and the Iron Pier (lower left corner), and formed the Manhattan Beach Company. Merrill, along with his two brothers, was interested in increasing real estate values rather than developing the pier area for the shipping trade. Prospective buyers were brought over the sand dunes by way of surrey carriages from adjacent Hermosa Beach. Merrill's office building is in the upper left of the photograph.

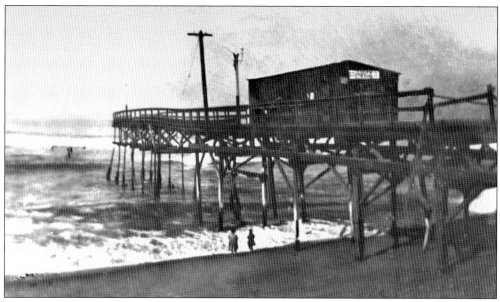

During its existence, the Iron Pier remained virtually the same except for the addition of electric lights on the deck. The building accommodated fishermen with a place to buy bait, a cup of coffee, and perhaps a 5¢ cigar.

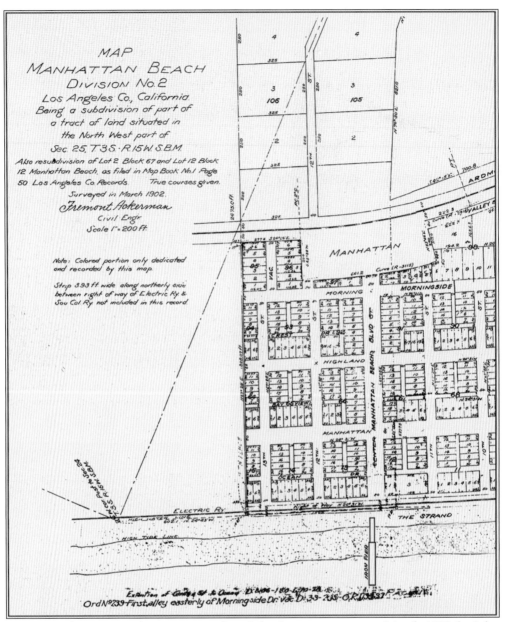

Fremont Ackerman, civil engineer, produced the first survey map in March 1902 for John Merrill. The location of the Iron Pier as an extension of Center Street is indicated in the lower right corner.

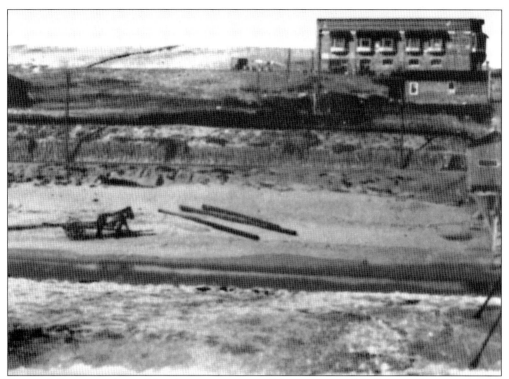

Some of the materials used for the construction of the pier arrived by boat and were unloaded offshore into the water. After the timbers floated in along the beach, mules were used to drag them into place.

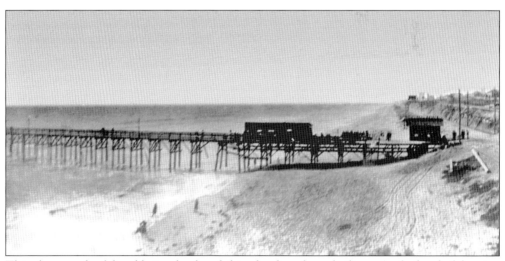

This photograph of the old pier clearly exhibits the three-legged pilings. At the head of the pier, a small real estate office was used by the Manhattan Beach Company. Situated at the Center Street train stop, it proved to be a good location for debarking passengers from the "Red Car" to be conveniently introduced to available property.

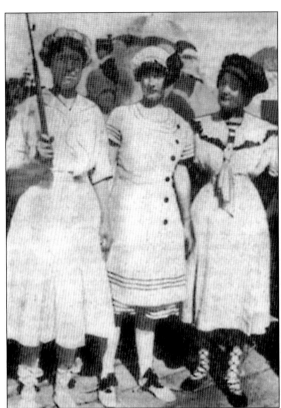

In 1906, these ladies appeared in one of the first bathing beauty contests held in Manhattan Beach. The pier also afforded a great location for a number of films. In 1907, the Kalem Company filmed the chariot scenes for the original 400-foot, single reel, 14-minute *Ben Hur.* As this was an unauthorized use of the story, the publisher and his son, Henry Wallace brought suit. The case became a landmark decision.

In 1908, as Manhattan Beach citizens continued to struggle against shifting sands, the pier was a tourist delight. Visitors strolled the boardwalks and went out to the end of the old pier to have their pictures taken. Note the "life service" safety device hanging on the rail.

On warm summer days, ladies from the Neptunian Woman's Club donned their swimming attire. The club, founded by 10 local women on March 26, 1909, was the first philanthropic organization benefiting both social and educational programs.

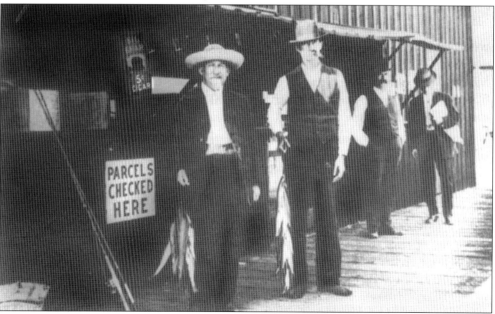

While the ladies enjoyed the sun, surf, and sand, the gentlemen preferred to spend the day fishing from the pier. The sea abounded with a variety of fish—yellow fin, bonito, halibut, sea trout, and bass, to name a few.

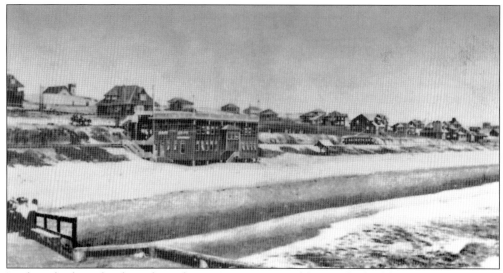

Looking back at the shore from the city's pier, one could view the bathhouse situated at the foot of Eleventh Street. Built in 1901 by James G. Cortelyou, a pioneer real estate developer, the structure offered a rooftop garden where lovely summer sunsets could be enjoyed. In addition, it had a restaurant famous for its clam chowder.

In late February 1913, a rainstorm all but paralyzed the area. Within a 24-hour period, the heavy rainfall washed the Pacific Electric rail beds away. Rail service was diverted and the town's people witnessed the break up of the "Old Iron Pier."

Two

CREATIVE YEARS

In May 1914, the Manhattan Beach Pier and Beach Association were formed and property owners considered the construction of another municipal pleasure pier. The board of trustees decided to sell more land, and actively sought an increase in tourism. What better attraction than to have a grand fishing pier? In August 1914, the board submitted Ordinance 99 to the voters, for the acquisition, construction, and completion of a wharf. The $75,000 bond issue failed to pass by 168 to 170 votes. For the next two years, there was lively discussion between those who wanted the facility and those who did not. Eventually, on January 20, 1916, a $70,000 bond for the pier and pavilion was approved. A month later, on February 16, Ordinance 170 was presented to the trustees, providing for the issuance of bonds for the pier. Because of injunctions against the issuance of pier bonds, special engineer A. L. Harris was prohibited from pier drilling and sounding. The injunction ended in favor of the pier and its pavilion; a public meeting was held to allow comments on plans for the pier and pavilion.

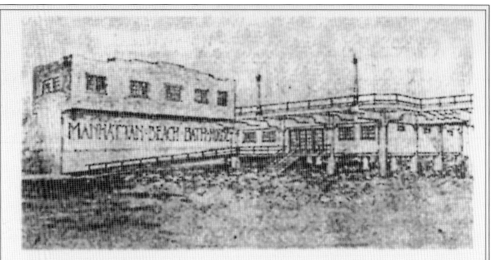

Ultramodern bathhouse was built in 1921 at the head of the pier; it accommodated 360 bathers.

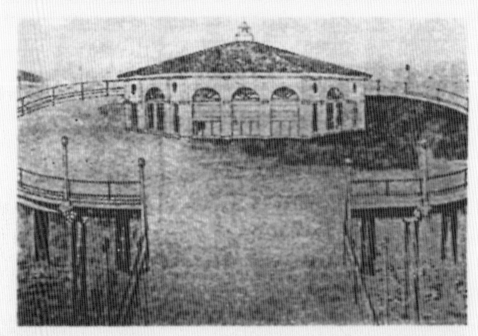

Manhattan's most historic site may be the Pier Pavilion, built in 1921. The exterior was finished in stucco and the roof was covered in Spanish tile. Large goose-neck reflectors were installed around the building; it was visible for miles up and down the coast.

This rendering, commenting on the features of the pier, appeared in a booklet entitled "The Waterfront of Manhattan Beach" written by Linda Chilton McCallister.

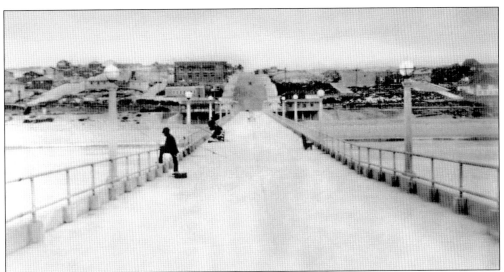

In 1916, A. L. Harris, special engineer for the city, designed and submitted the plans stating the practical and unique reasons a round-end pier would be desirable to the California coastline. "It is a feature that hasn't been, as yet, brought out on any other pier along the coast that I know of . . . another reason for having the circular end is that it is much stronger against the action of the waves." Approval by the city trustees, however, was not given until September 19, 1917.

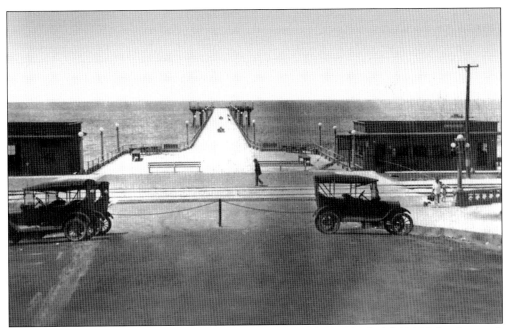

The pier contract was awarded to engineer George Harding, who bid $61,000 for the pier's construction. After working on the pier for a year, Harding, with his many unpaid debts, abandoned the effort when World War I caused a rise in the cost of materials. By September 1918, with $35,000 having been spent by contractor Harding, the project was turned over to A. L. Harris.

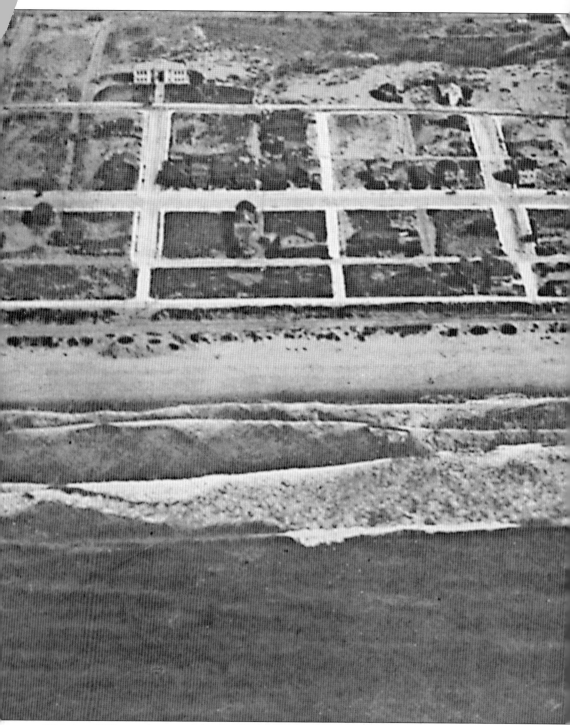

This is a 1921 aerial view of the finished Municipal Pier. The image was used on a brochure

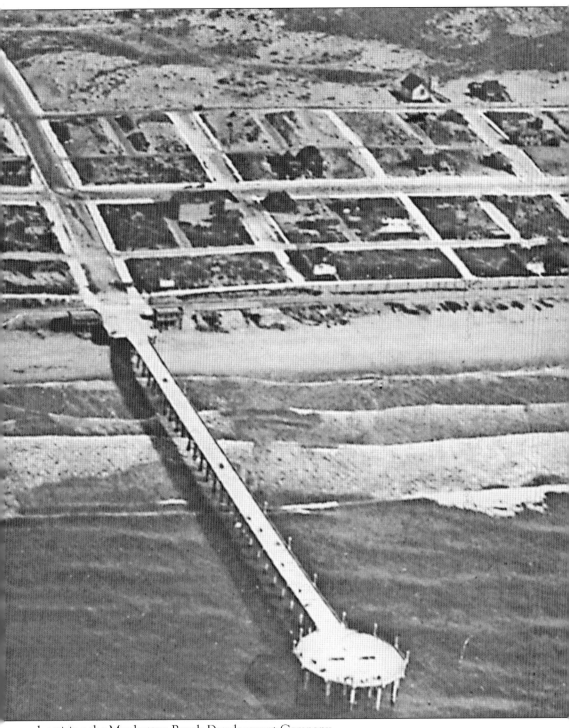

advertising the Manhattan Beach Development Company.

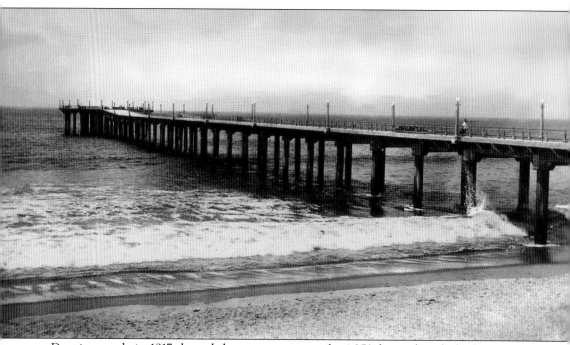

Drawings made in 1917 showed the causeway was to be 1,250 feet in length, leading to a 100-foot-diameter area. Upon this circle, a 64-by-70-foot pavilion would be constructed. However, as built, the Municipal Pier (pictured above) was 928 feet long by 25 feet wide. Excluding the causeway segment between the four-percent rise and the end of the pier, it had reduced the length. The deck of the causeway cantilevers four feet over both sides of the pier. Originally it spanned approximately 760 feet of water; today only 300 feet of the pier are over water at mean tide. The bonds for the construction of the pier were bought by the Foundation Company of the Torrance-Marshall Company. With a promise to complete the pier in 90 days, the work started. But due to disagreements, H. W. McGee replaced engineer A. L. Harris. During World War I, piles became buried nearly seven feet deep under tons of sand. By late 1919, all the sand was pumped out of all piles, and each pile was sealed. The construction documents indicated that the pavilion area and causeway were supported by 30-inch-diameter cylinder piles. The concrete piles were fabricated in continuous lengths and installed by jetting. The depth of penetration for the piles varied from 15 feet to 20 feet. On July 5, 1920, to celebrate the grand opening of the new Municipal Pier, a dance, parade, and other activities were held. Previously, a memorial service was held on the unfinished pier in 1918 to honor the memory of the boys who died during World War I. This was the first public gathering to take place on the new structure. At last, on November 18, 1921, the Manhattan Beach Development Company announced that work would commence on the pavilion designated for the end of the pier at a cost of $15,000.

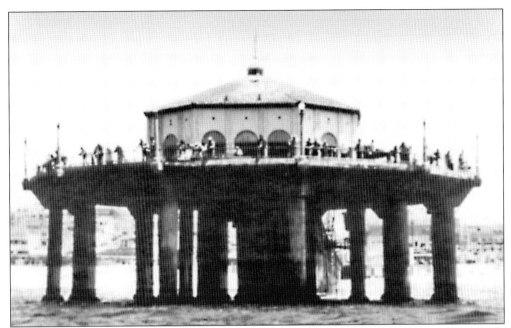

When the 64-by-70-foot pavilion opened on July 4, 1922, it offered a bait shop, tackle rental, and restaurant. A. L. Harris took this photograph from the ocean, looking east at the end of the newly completed pier.

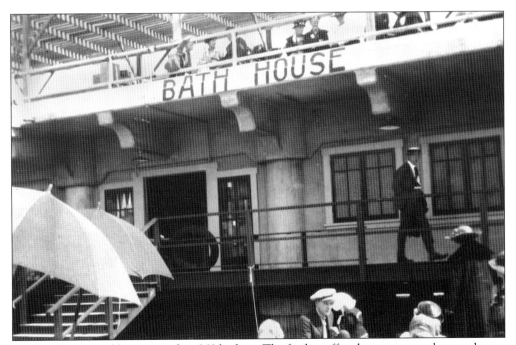

The bathhouse could accommodate 360 bathers. The facility offered restrooms, a place to change clothes, and beach umbrella, locker and bathing suit rentals. The lattice-covered area above the bathhouse provided gas-burning stoves and picnic tables.

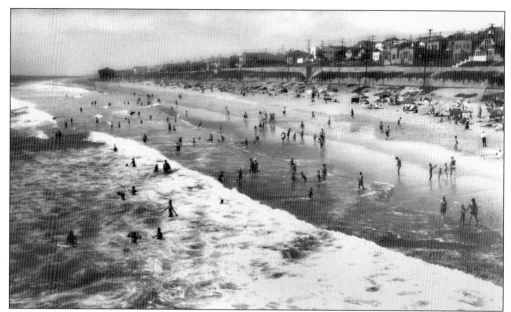

This photograph looks north from the pier. During the summer months of the Roaring Twenties, the beach population doubled as hundreds of residents and visitors enjoyed the shore. At times, the beach was so crowded that space for even a blanket was at a premium. By 1927, there was fear that the pier's popularity would change the nature of the town as the influx of outsiders increased.

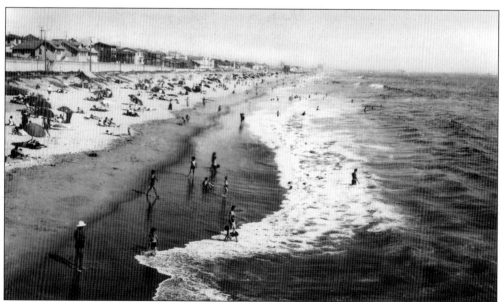

This photograph looks south from the pier. Fewer swimmers were attracted to this side of the pier, though it provided equal access.

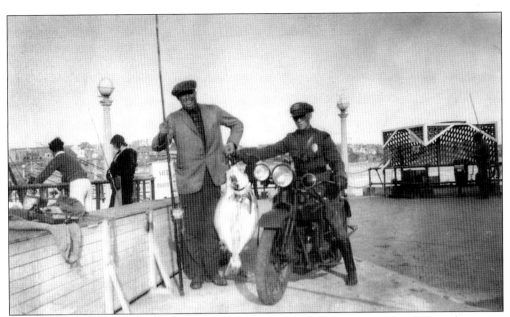

To keep law and order, chief of police Fred J. Garvin patrolled the pier frequently. Here he is seen with a friend and his freshly caught halibut.

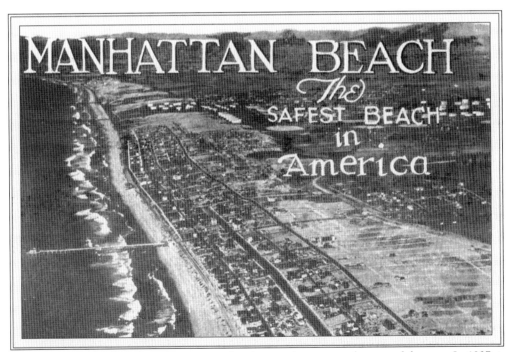

The beach surrounding the pier was considered a very important element of the area. In 1927, it was hailed as the "Safest Beach in America," enticing hundreds of visitors to its warm sands. At the end of the decade, many of those summer visitors became permanent residents.

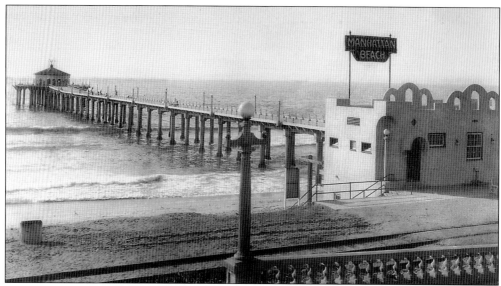

In 1923, another feature was added to the pier. The Metlox Company, a local ceramic manufacturer, installed an electric sign that read "Manhattan Beach." Supported by two iron poles and stretching across the width of the pier, its large ceramic tile letters could be easily seen by day and were prominently illuminated at night. The sign was also visible to passengers aboard the "Red Car" rail system as they approached the pier.

In 1926, providing a much needed resource for the fishing population, Oscar E. Bessonette built and operated a bait and tackle concession at the end of the pier.

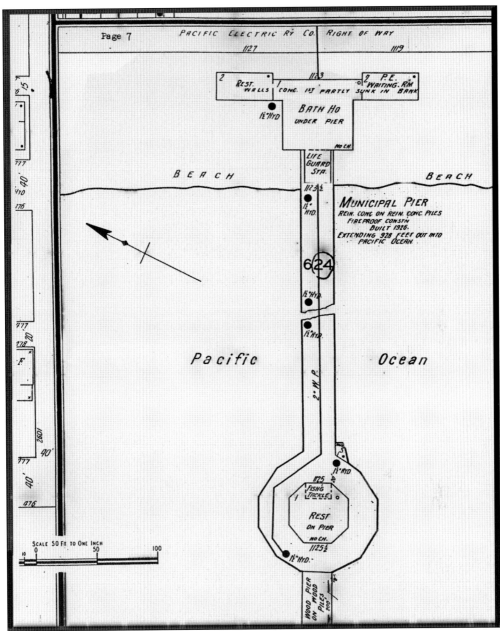

The debate over a planned extension of the pier heated up in 1926 when the city council granted U. T. Thompson the franchise for the erection of a fishing and pleasure pier. Subsequently in February 1928, Capt. A. J. Larsen, who had purchased the franchise, proposed a 200-foot extension featuring ornamental lights, electricity, gas, and water at a cost of $10,000. By April, the winning bid for its construction went to the Krantz Company.

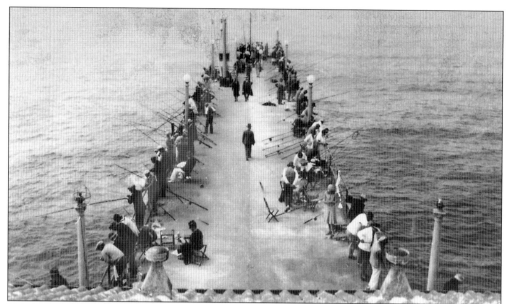

Originally a Los Angeles firm had received a 10-year franchise from the city to construct a 1,000-foot pier extension. This expansion was to be divided into private fishing stations, making for a less crowded area. "A better class could secure a place in which they could fish to their hearts' content without having to rub elbows with crowds of strangers of dubious character as in the case of most fishing points of vantage" was a selling point for the exclusive project, and typified public attitudes of the times. Eventually the firm abandoned the project and gave up the franchise.

Pilings to support the 200-foot extension were driven into the ocean floor. For the purpose of mooring a deep sea fishing barge as well as private yachts, individuals financed construction. Due to the many work delays, the city council extended the time frame 30 more days. By July 1928, the lengthening of the pier was completed. However, the ambitious and exclusive plans for the barge-type operation encouraged a "bad" crowd.

"Young blades" of the late 1920s pose for this picture in their summer "straws" while standing on the north side of the picnic area at the beginning of the pier.

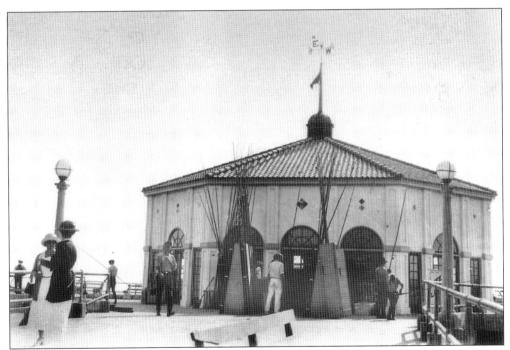

The "Roundhouse" at the end of the pier separated the main causeway from the newly completed extension.

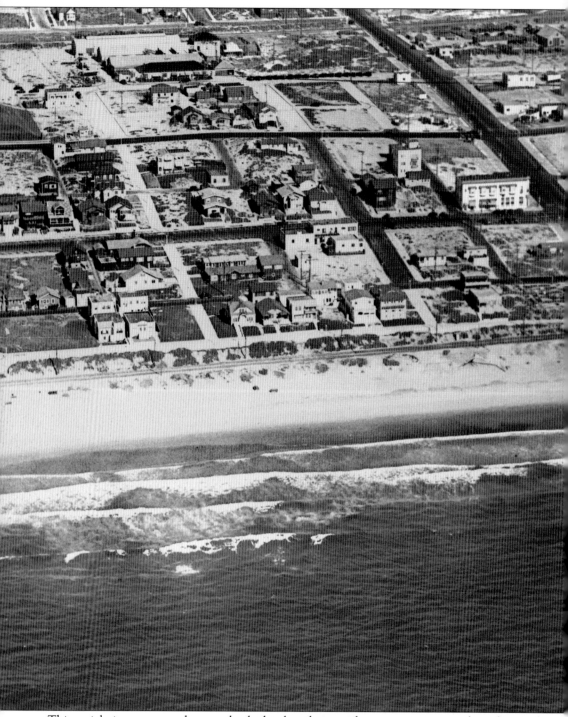

This aerial view captures the completely developed pier with its unique octagonal pavilion and

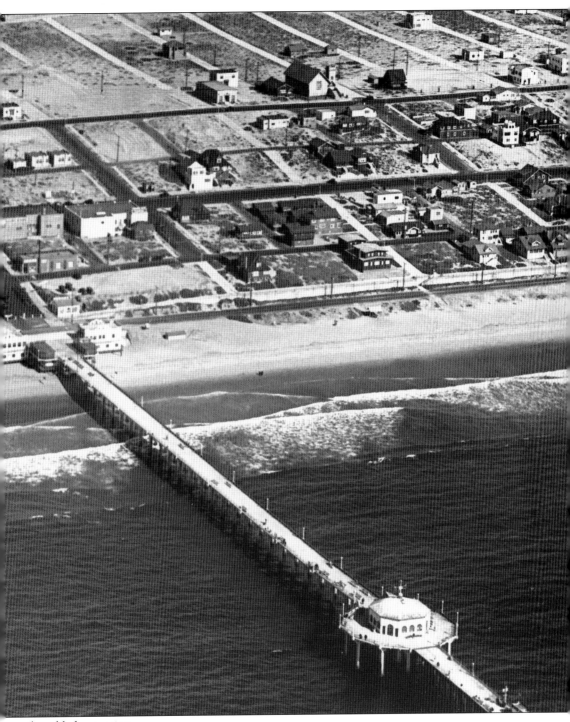

the added extension.

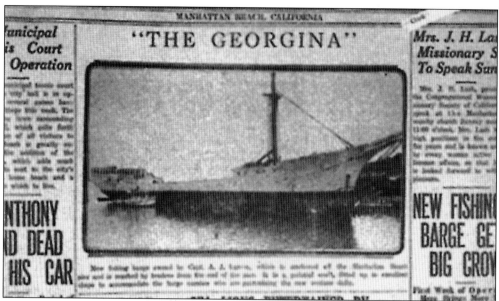

"THE GEORGINA"

In August 1928, with the construction of the Manhattan Beach Pier extension completed, Captain Larsen's barge, the *Georgiana*, arrived to begin fishing operations. The barge had been anchored in the San Pedro Harbor. Converted from a pleasure vessel into a fishing barge, it now anchored offshore Manhattan Beach. For the next eight years, Captain Larsen would operate the barge as well as managing the pier's extension. He would finally sell the barge and give the extension title to the city.

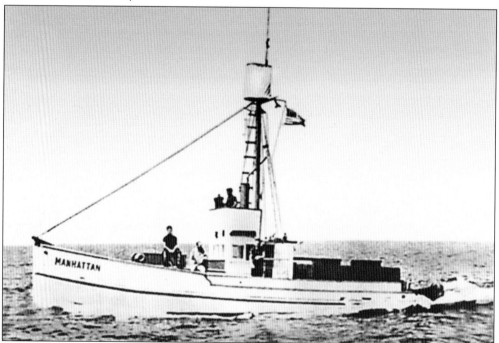

During the 1930s, the 45-foot bait boat the *Manhattan* served as a water taxi between the Manhattan Pier extension and the fishing barge *Georgiana*. In April 1935, the *Georgiana* went aground during a spring storm and was never used again.

32

Three

THE GOOD LIFE

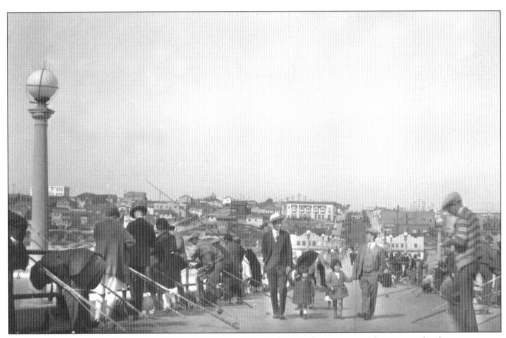

As Manhattan Beach entered the third decade of the 20th century, there was little to suggest that the 1929 great bull market crash was making much of an impact. Businesses were opening, and the fish were virtually jumping onto the pier. Much of this chapter is devoted to the people who passed before the camera to record their catch of the day. In August 1930, an elaborate celebration marked the installation of fishing lights mounted on the pier. Firework displays were detonated from the pier as people from all parts of the state came to dance—after 300 pounds of cornmeal had been scattered over its surface. The pier was also used as a port of call for a water taxi between Malibu to the north and Redondo Beach to the south. For two years, the city received five percent of the revenue from this traffic. During the Great Depression, beach lovers may have felt the "sun, sand, and surf" was free, but the city knew better. Beach maintenance was a continuing expense that included cleaning, lifeguarding, and policing. In February 1930, Los Angeles County took responsibility for the upkeep of the beach. In June of that same year, the county brought in heavy duty cleaning equipment thus removing dangerous debris from the sand as well as installing playground facilities.

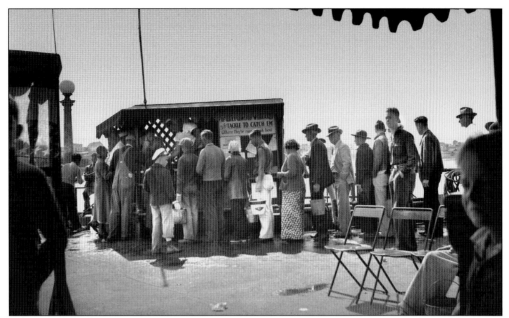

The bait shack that Oscar Bessonette constructed was well used by men, women, and children. The sign that appears in the upper corner of the structure humorously reads, "If They Swim–We Have the Tackle To Catch Em'. " [*sic*]

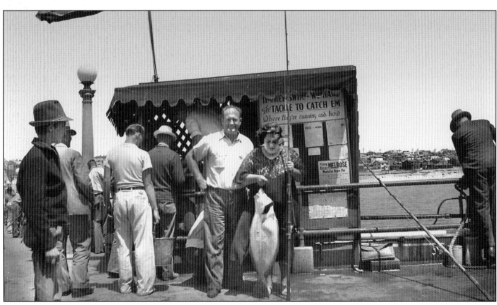

It was quite common for fishermen to have their photograph taken with the catch of the day. Many of these pictures were used as souvenir postcards.

During the 1930s, many conveniences were provided for the thousands of annual visitors to the pier. Most popular was the ability to rent complete fishing gear including poles, reels, and line for $8. Even a sink with running water was available for cleaning freshly caught fish.

In the early 1930s, people found fishing from the pier a true "fisherman's paradise." There was a very social atmosphere, with many people eating at Mr. Brockey's restaurant, located in the Roundhouse at the end of the pier.

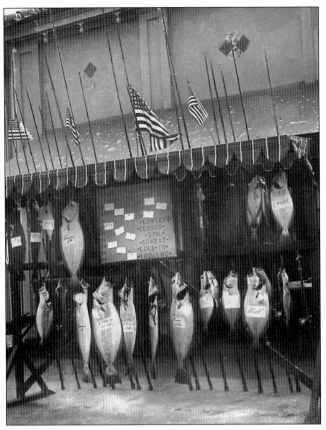

Annual fishing derbies, where prizes were awarded in different categories, were extremely popular. In 1933, during a two-month period, fishermen caught 5,233 fish from the pier. The waters offered a variety of specimens including yellowtail, barracuda, halibut, mackerel, perch, king fish, bonito, flounder, herring, bass, and black sea bass.

On weekends and holidays, many visitors arrived from around Los Angeles County by the Pacific Electric Red Car. As this postcard image shows, hundreds lined the pier's railing delighting in the sport of fishing.

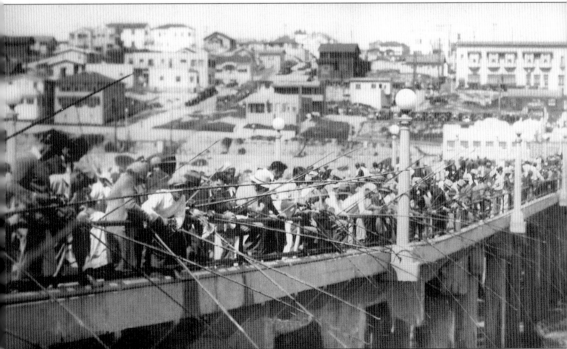

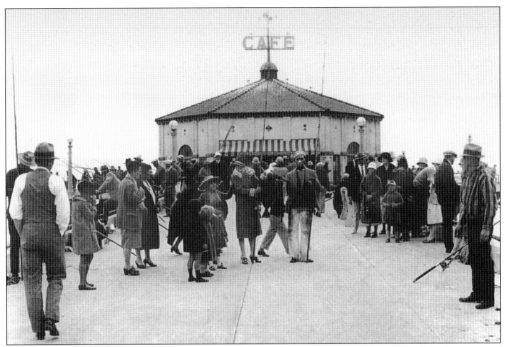

During the week, the pier and beach were less crowded. Locals could relax and take advantage of open railings and empty benches where fishing was more peaceful and a warm sun and cooling sea breezes might be enjoyed in solitude.

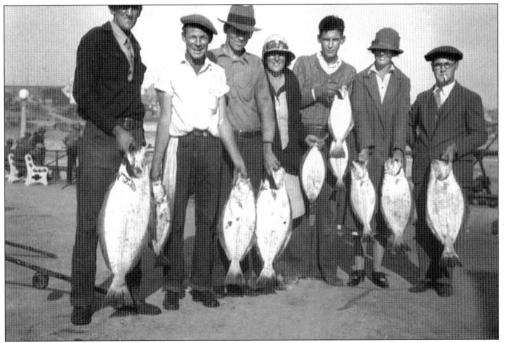

Proud folks are seen displaying the catch of the day. Hundreds of people were drawn to the Manhattan Beach Municipal Pier due to the large fish runs during the late 1920s and into the 1930s.

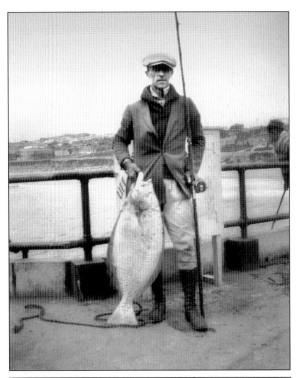

There were plenty of fish for all, including seabirds, which hovered around the pier. The surrounding waters were noted not only for their abundance of fish, but for the size of the species. Any fisherman worth his rod and reel could count on taking hoome a significant catch.

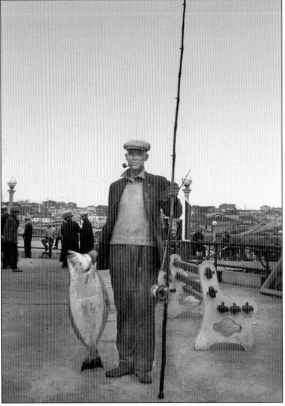

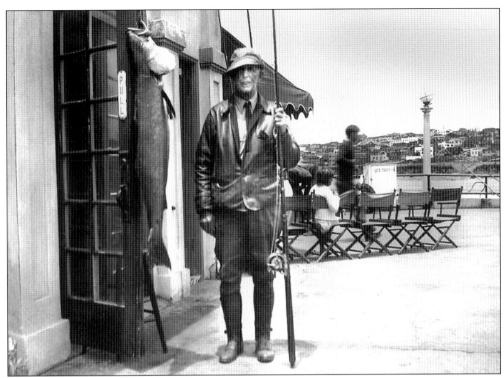

This gentleman proudly stands next to his 88-pound barracuda, which was hung on one of the Roundhouse doors.

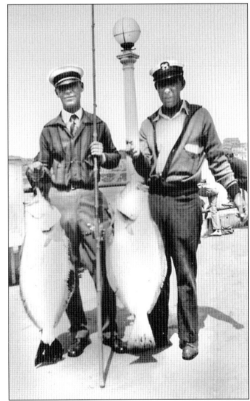

Much of the "good life" revolved around events at the Municipal Pier, attracting thousands of people each year. Naturally, fishing was the number one activity. In May 1933, records show there were 4,323 fish caught from the pier alone.

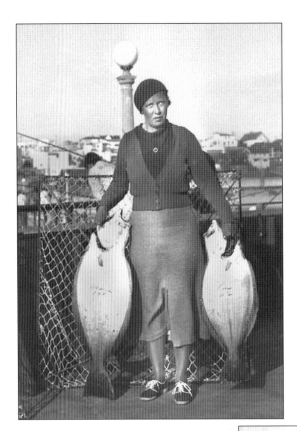

Men weren't the only fishers who could "reel 'em in." The ladies frequently posed with their freshly caught bounty as well.

During the Great Depression, many people, including families, would come to the pier just to catch their evening meal. Often the fish were cleaned and cooked on facilities provided on the pier.

In the 1920s and 1930s, some of the largest fish were caught off the Manhattan Beach Municipal Pier as well as the barge, the *Georgiana*. Catching black sea bass that weighed 200 to 600 pounds was not uncommon. A pulley and rig were built on the pier for weighing and displaying these huge creatures. It took many hours to haul one of these large fish onto the pier. While the names of the fishermen seen here are unknown, their accomplishments were proof of the rich marine life that once swam these waters.

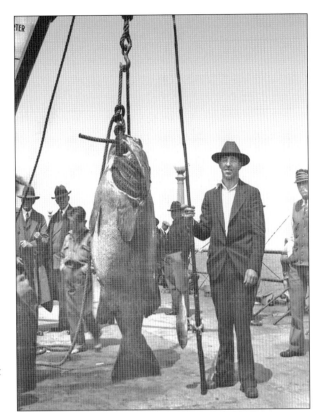

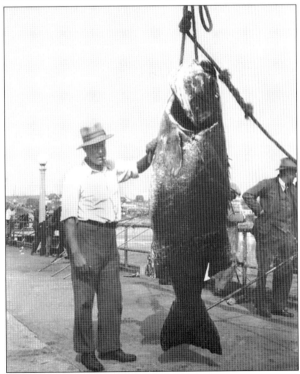

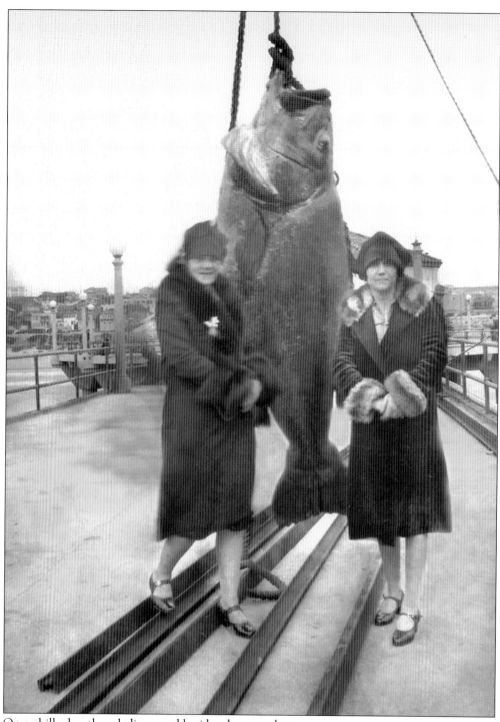

On a chilly day, these ladies posed beside a large sea bass.

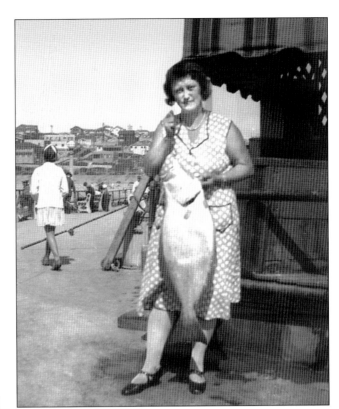

Women enjoyed the sport of fishing as much as the men and boys. They could be seen on the pier during all seasons.

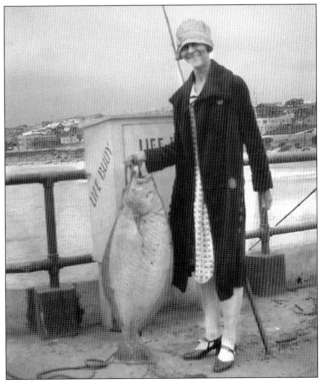

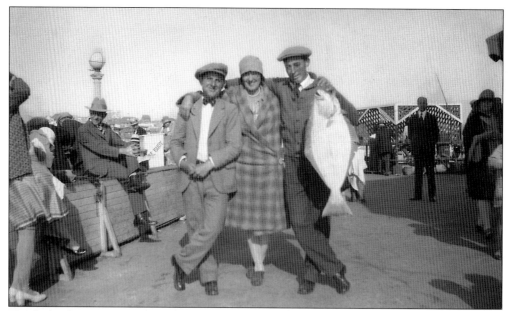

"Smile for the camera, please." In their city attire, these happy folks quite likely came down to the pier by way of the "Red Car," Los Angeles's early rapid transit rail system.

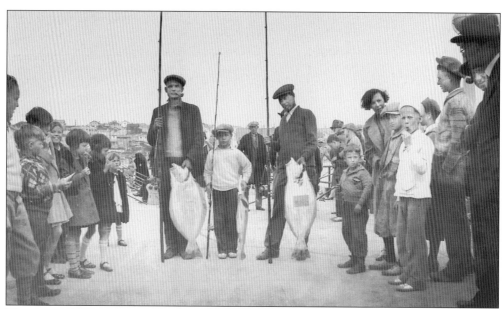

There was always a cameraman ready to record the catch, and curious bystanders make the picture an event. In the 1920s and 1930s, the sport of fishing was a combination of entertainment, camaraderie, and a source of food for many of the local residents.

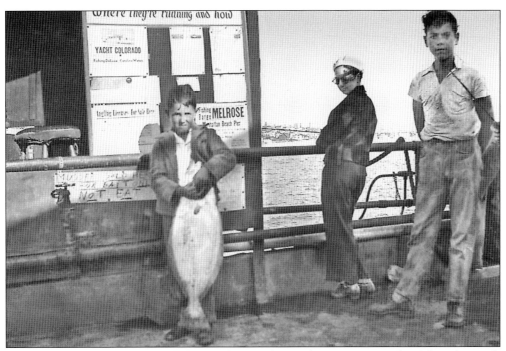

Many youngsters would spend all day on the pier during the summer months. Often the catch was almost as big as they were.

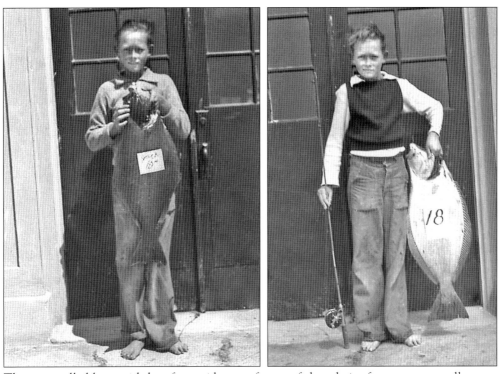

These overalled boys with barefoot pride pose for proof that their afternoon was well spent.

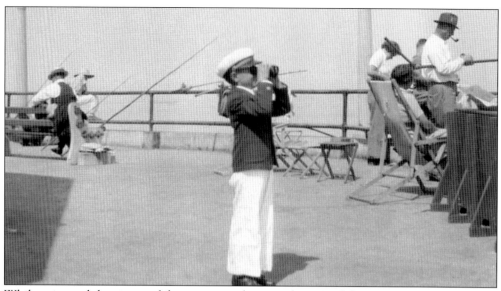

While most used the pier as a fishing venue, others simply enjoyed the over-water vantage point. A young lad in nautical attire is seeking a binocular view of the USS *Texas*, anchored offshore in observance of Armistice Day.

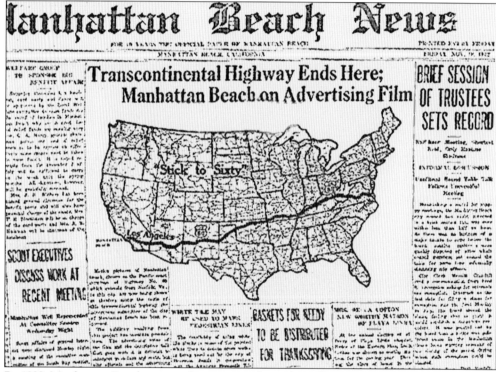

By 1932, Manhattan Beach was on the main north-south traffic artery in the South Bay area. It was suggested at the time that the transcontinental Highway 60 end at the Manhattan Beach Municipal Pier. A film was produced showing the beachfront, Municipal Pier, crowds of fishermen, and a fishing barge, all to promote the city and the proposed highway terminus idea. Highway 60 started in Norfolk, Virginia Beach, and would then stretch from sea to shining sea.

The Roundhouse was showing wear from the many storms that battered the pier and extension. Moisture penetrating the pilings had caused the concrete to peel off, exposing the reinforcements to the corroding action of salts in the sea and air. After the city engineer advised that work needed to be done to repair the damage, Mayor George Knox suggested that an attempt be made to obtain federal funds.

The photograph looks north from where the Municipal Pier, trolley tracks, and Strand meet. In 1935, the Pier Project work began, funded by federal monies. Engineer Rood oversaw the cleaning of exposed steel reinforcement, replacement of concrete, and the scaling of barnacles from the pilings. The estimated cost was $8,318.

While many young people were engaged in the art of fishing, the Ward children enjoyed a sunny day on the sand in front of their grandmother's home at Twelfth Street and Strand. Pictured, from left to right, are William, Shirley, and John.

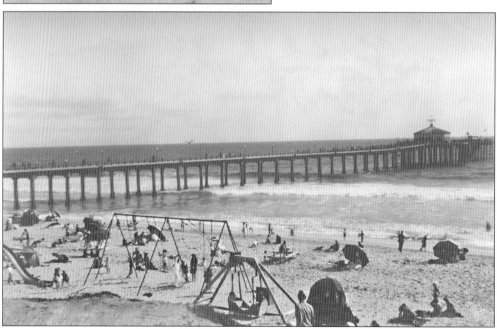

In 1930, Los Angeles County took responsibility for the beach from Thirteenth Street to Thirty-seventh Street. The county brought in heavy cleaning equipment to remove dangerous debris from the sand, and set up playground facilities.

The average Manhattan Beach resident was probably not as interested in who owned the beach as they were in what people wore to the beach. The same "flapper era" that brought in short skirts also introduced a trend of more comfortable sports clothes and briefer bathing suits. Here, John H. "Whitey" Wilkins and his son Johnny stroll across the sand.

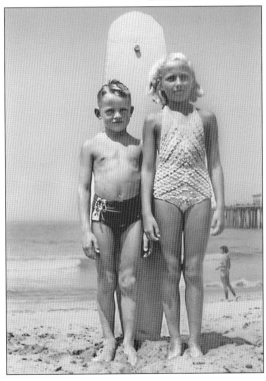

In 1931, it was neighboring Hermosa Beach that first allowed children under the age of 12 to appear on the beach clad in only trunks. It was felt that maximum benefit from exposure to the health-giving rays of the sun could be had while still presenting an appearance that was not offensive. By 1935, Manhattan Beach dress ordinance 395 was approved— allowing men to wear only trunks and women to wear two-piece suits. However, they had to be covered when appearing on the Strand or pier. Here, Johnny and Carol Wilkins are ready for a surf ride.

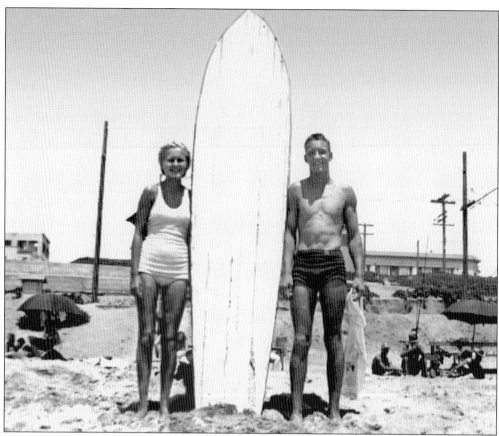

John Dole and friend Lynn Carver (later known as movie starlet Virginia Sapson) stand beside a surfboard made by Dole. The board was one of the first in Manhattan Beach made from laminated two-by-four-inch soft pine. Much of the wood was acquired by cutting down city road signs located in east Manhattan referred to at the time as the "back country." John was a popular figure in a young men's group known throughout the beach community as the "Water Rats."

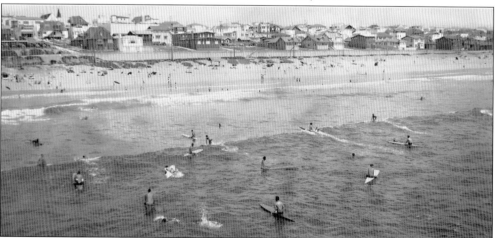

Although thousands of people would flock to see firework displays launched from the pier by the Golden State Fireworks Company, hundreds came just to ride the waves.

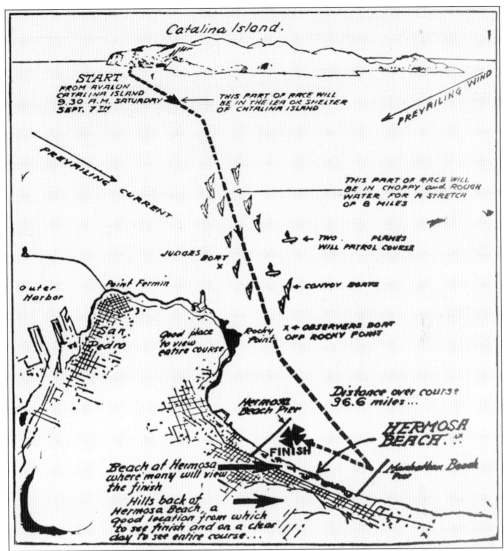

On August 2, 1935, after months of negotiations, Logan Cotton, chairman of the junior chamber of commerce, announced that the stage was set for the great Aquaplane Race. The race was regarded as the greatest single sporting event to be held on the California coast that year. Thousands of people crowded the beach to watch some 100 competitors. The public standing along the shoreline could hear the progress of the event from a speaker system furnished by Standard Oil Company and Safeway stores. Riders stood on two-inch boards while being guided with a rope line and pulled behind speedboats. These boats, consisting of a driver and mechanic, often reached speeds of 50 miles an hour. The race crossed the channel from Avalon Bay on Catalina Island to a buoy off the Manhattan Beach Pier before turning southward to a first stage finish line off the Hermosa Beach Pier. After making the sensational 44-mile crossing, riders were to leave their boards at a designated spot outside the breaker line and then swim to the beach for the final finish line. Both men and women competed in this popular annual race, which continued for several years.

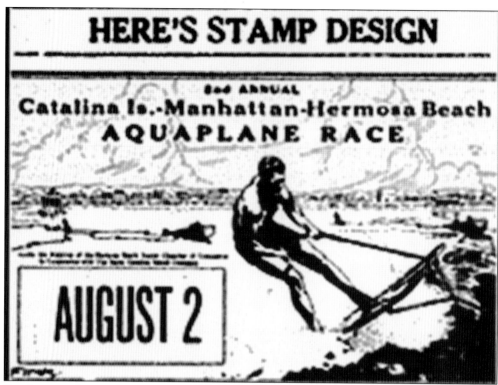

HERE'S STAMP DESIGN

2nd ANNUAL
Catalina Is.-Manhattan-Hermosa Beach
AQUAPLANE RACE

AUGUST 2

For the second annual race, a special blue and yellow Aquaplane Race promotional stamp was offered for use on all outgoing mail. Design entries were submitted from as far away as Santa Barbara and San Diego. The winning entry was designed by Rader Fink, a young newspaper artist.

Another promotional idea for the race was Bob Jean and Tom Marshall applying the Aquaplane Race stamps to the bathing suit of Ava Cassell. Aquaplane races preceded the paddleboard and dory competitions.

As an advertisement for the upcoming Aquaplane Race of 1937, John Campbell, then a postman, delivered a letter by aquaplane from Manhattan Beach mayor C. W. Lockry to Louis Crandall, mayor of Avalon on Catalina Island. Campbell crossed the channel in less than an hour and 40 minutes, giving him good training to be able to finish third in that race.

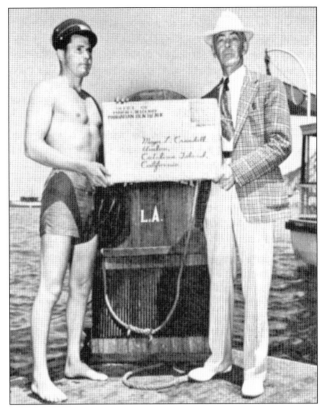

John W. Campbell (1913–1996) was a member of a Manhattan Beach pioneer family and served in many organizations as well as being assistant Manhattan Beach postmaster.

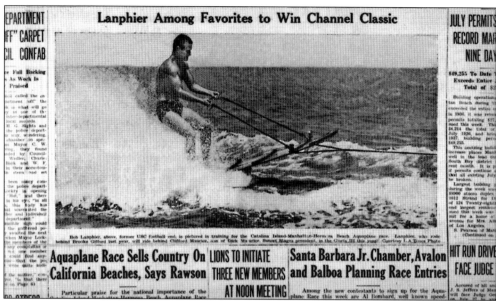

In 1937, racer Bob Lanphier, former USC football end, was one of the favorites to win the Channel Classic.

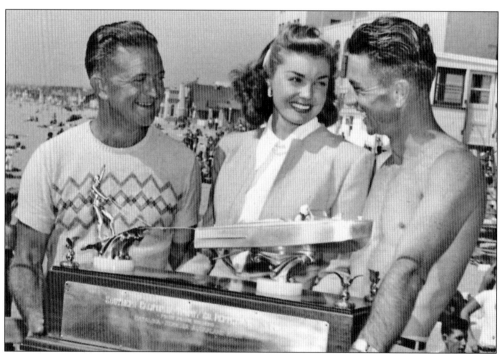

Over the years, the Aquaplane Race attracted many dignitaries and popular celebrities. Well-known swimming athlete and movie actress Esther Williams is pictured handing the winner's trophy to Bill Burred.

Four

Cloudy Skies Turn to Sunshine

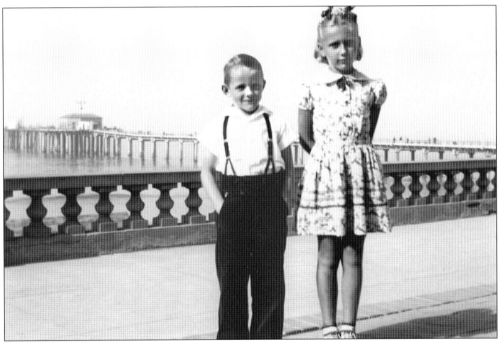

In the mid 1930s, the Municipal Pier End Cafe was seriously damaged. What Mother Nature didn't do with heavy winter storms that swept across the South Bay, vandalism and burglary did. With pilings washed out during the storms of 1937, needed restoration of the pier was obvious. In order to obtain county funds, the city council, in August 1938, designated the Municipal Pier as a continuation of Center Street (now called Manhattan Beach Boulevard). As replacements, 17 new pilings would be driven into the ocean floor. The pier extension beyond the Roundhouse can still be seen in the photograph above as John Wilkins and his sister, Carol, stand on The Strand. However, it was not long before it too met its end in stormy violence.

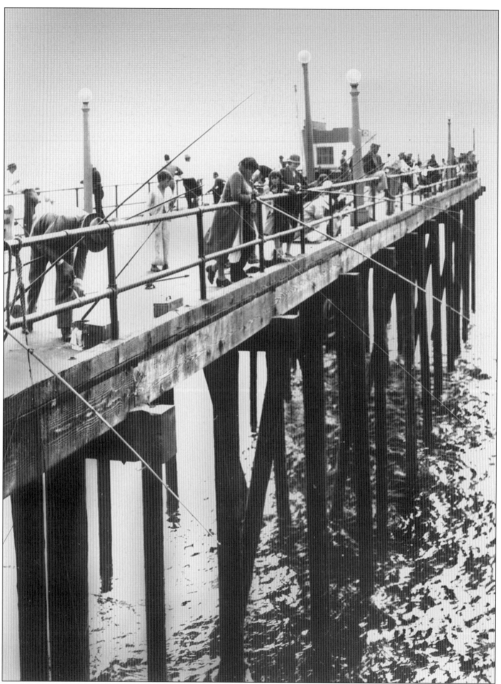

People were still fishing from the pier extension, but the fish that were so abundant along the shoreline were slowly disappearing from the waters of Manhattan Beach. The multitudes of people who once came primarily for fishing would soon be attracted to the pier for other activities.

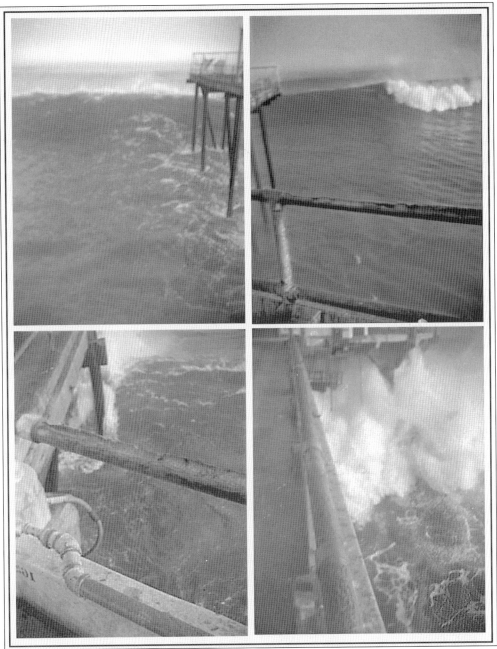

In the early hours of January 9, 1940, residents awoke to a violent storm with high waves and winds that were extremely strong. The pier extension took a fatal beating when, shortly after 4 a.m., the heavy surf carried away approximately 90 feet. Suspended from the underside of the top deck, several pilings became loose at their base. Swinging like battering rams, they wiped out nearly half of the structure.

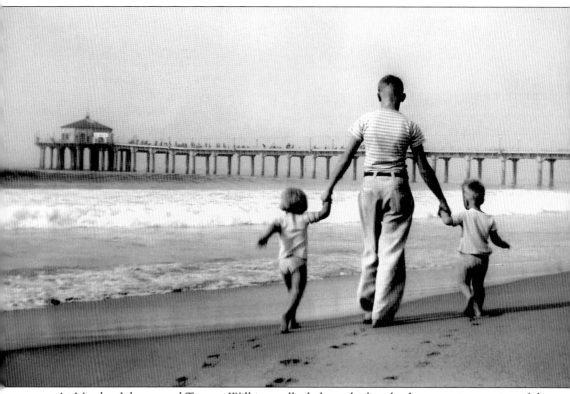

As Martha, Johnny, and Tommy Wilkins walked along the beach, they now saw no sign of the pier extension. In 1941, the remaining portion of the extension was uprooted, turned over on its side, and carried out to sea. It later floated to shore almost intact. With the boat landing, winch, gasoline station, and lifeguard dory gone, the city saw no reason to replace the missing structure. Another changing event at the shoreline was the continuing court cases involving Neil McCarthy's section of beach. McCarthy purchased the land in 1938 from James Cortelyou. Unable to sell the property, McCarthy tried unsuccessfully to subdivide the tract of beach into 60-foot beachfront parcels. Resolution came in 1943 when the city passed a decree asking the county to buy McCarthy's private beach. However, it would take the state until 1956 to agree to purchase the property. During his ownership, Mr. McCarthy installed a barbwire fence (later to be replaced with smooth wire) around his property from First Street to Thirteenth Street. He charged admission to the gated area, much to the community's displeasure. Eventually, the fence was destroyed by a storm and was never replaced.

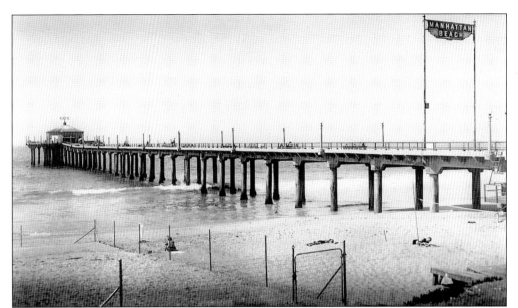

This photograph shows two things that no longer exist—the controversial McCarthy fenced-in plot of beach and the once prominent Metlox crafted sign reading "Manhattan Beach" at the pier's entrance.

As part of a beautification campaign launched by the chamber of commerce in 1948, the Lions Club contributed a new coat of paint to the chamber office building located at the entrance to the pier.

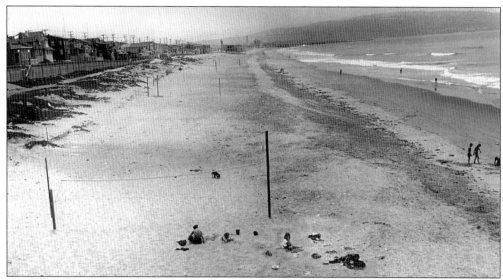

In reaction to the city's refusal to accept the asking price of $300,000 for his property, Neil McCarthy would not cooperate in keeping his beach free from litter after the fence was blown down. Not until 1955, did he even allow the Los Angeles Department of Parks and Recreation to clean the area. In 1956, the property was sold to the state's Commission of Beaches and Parks for $250,000. The sale of the privately owned beach ended a 15-year battle.

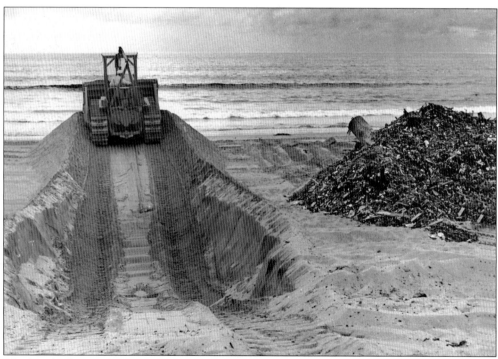

The beach-cleaning machines raked to a depth of six inches and uncovered all types of litter, from beer cans to bottles and paper.

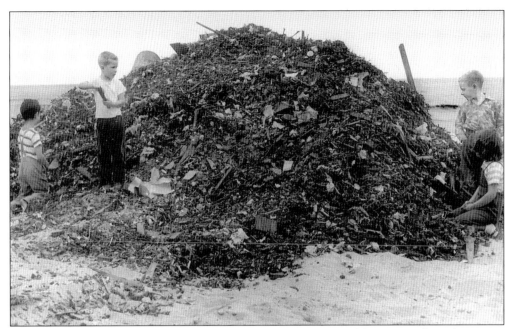

After the machines sifted through the sand, a large quantity of debris was collected. It was a fascination to youngsters as they examined the uncovered rubbish.

Back in 1938, Redondo Beach had started a breakwater project. By 1948, it was evident it was causing the sandy shore of Manhattan Beach to widen. Prior to this construction, the beach had been very narrow, as evident in earlier photos. Gradually, thousands of cubic yards of sand accumulated north of Redondo Beach while increasing Manhattan Beach's width. Looking north from the pier, the camera captured the splendid shoreline of today.

With the cleanup finished and a widening sand area, it was time to show off a pristine beach. And what better way to do that than by having a beauty contest. Pictured, from left to right, are Jerry Tugwell, of the Moose lodge; Lillian Russell, contestant; and William Suppe, Manhattan Beach mayor.

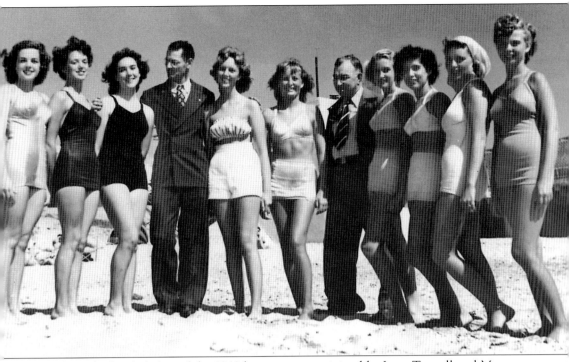

Pictured are the lovely ladies of the 1948 beauty contest, joined by Jerry Tugwell and Mayor William Suppe. To the right of Lillian Russell (second from left) is a very young Elizabeth Taylor, wearing a one-piece black bathing suit.

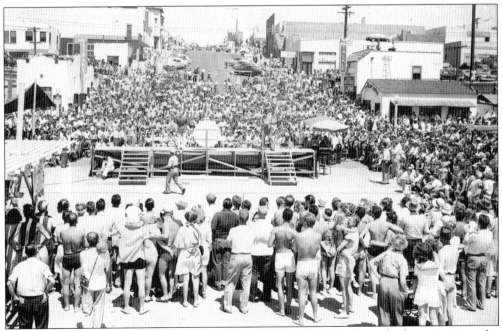

The contest was held at the foot of Manhattan Beach Boulevard where it joins the Municipal Pier.

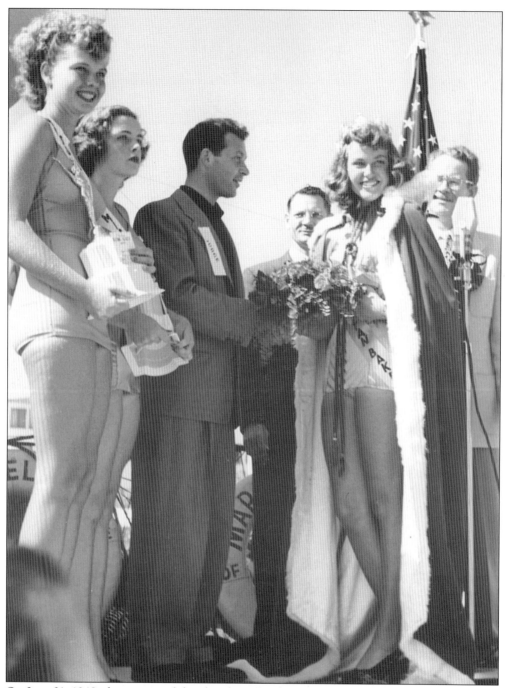

On June 21, 1948, the winner of the chamber of commerce's "Miss Manhattan Beach" beauty contest happily receives her trophy.

Five

SURF, SAND, AND STARS

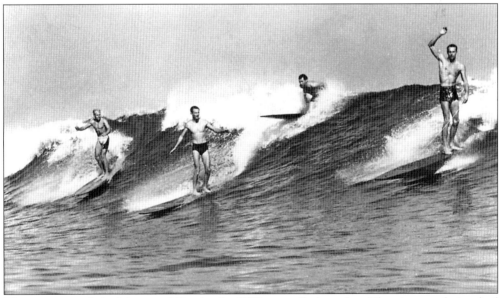

The area around the Municipal Pier in the 1950s was all about fun. The city population had been doubling every five years to reach approximately 18,000, with a city budget of $479,321. However, there were still repairs to be made on the pier. In 1953, engineers reported the need for such repairs as being urgent. "If work was done soon the pier should have a life for another 30 to 35 years before any more work would be necessary." In 1956, the state assumed the responsibility for the Municipal Pier, including plans for the County of Los Angeles to maintain the beach and to construct parking lots adjacent to the pier. The State Park Commission, however, reserved the right to demolish the pier if rehabilitation was too costly. Although the debate went on as to what work would be done on both the beach and the pier, most residents and visitors were more interested in surfing and playing volleyball. While surfers were riding the crests of the waves above, shapers made boards under the pier.

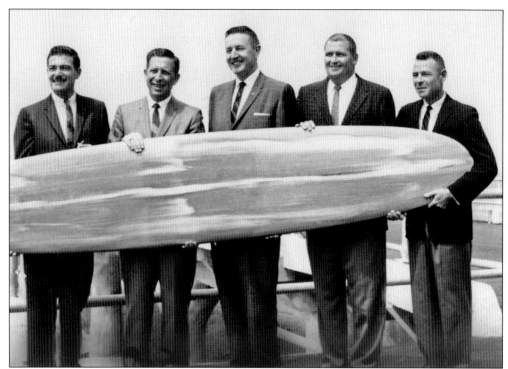

In 1955, the first paddleboard race committee was formed. Pictured above, the members of the steering committee, from left to right, are Robert Reuben, president of the chamber of commerce; Paul Garber, chairman of the Paddleboard Race; Lee Cave, Wyatt Galliday, and Jack Stearns.

It was county lifeguard Bob Hogan who suggested 50 years ago the idea of the Catalina International Paddleboard Race. Hogan worked in conjunction with the chamber of commerce to see the 32-mile race from Catalina to the Manhattan Beach State Pier come to fruition.

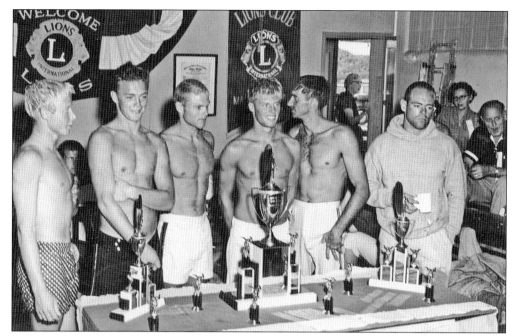

In September 1955, the first six men to finish the paddleboard race, from left to right, were Charles Reimers, Gregg Noll, Tom Zahn, Rickie Griggs, George Downing, and Bob Hogan, originator of the event.

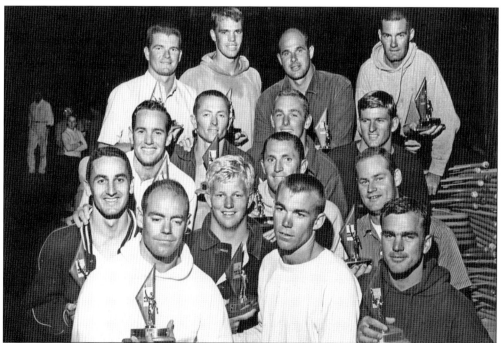

Over the years, the Catalina International Paddleboard Race was well attended by both entrants and spectators alike. The athletic challenge was considerable as the channel crossing could be rough and strenuous. The group of contestants pictured here are rightfully proud to display their trophies.

MANHATTAN BEACH
California!

WHERE LIVING ALL YEAR 'ROUND
IS VACATION EVERY DAY!
At the ocean edge of
Los Angeles County

The significance of surfing as a sport is evidenced by this promotional piece distributed by the chamber of commerce. It was the chamber who organized and promoted the International Surf Festival and the International Surf Festival Paddleboard Races.

The paddleboard contest drew crowds to Manhattan Beach. Spectators gathered at the foot of the pier on a warm sunny day in August for the event.

Hollywood celebrities frequently highlighted events. Paramount Studio star Valerie Allen stands on the back of a city Park and Recreation Department vehicle driven by Alex Bolyanatz, coordinator of the recreation program. Seen with Allen is Lt. Don Hill, county lifeguard. Allen had recently been featured in a motion picture with Bob Hope, Dean Martin, and Jerry Lewis.

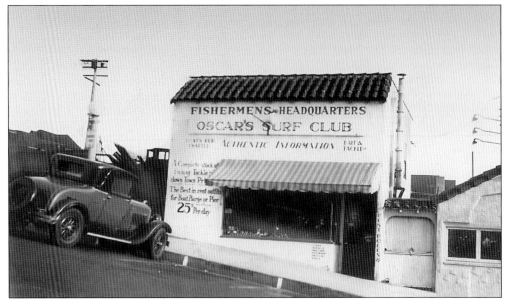

Oscar Bessonette, having lost his lease for operating the popular bait and tackle concession at the end of the pier, opens up this new fishing and tackle store in 1926.

Unfortunately, Oscar Bessonette was forced to close this store in 1956 due to the fact it was on land the state planned to use for a parking lot. In January of that same year, city manager Swanson announced the successful attempt to get the State of California to assume responsibility for the pier. This included plans for county maintenance and construction of parking lots adjacent to the pier.

Volleyball was invented in 1895 by William G. Morgan, who was the physical director of the Holyoke, Massachusetts, YMCA. The original name of the game was mintonette, derived from the word badminton. Since the idea of the game was to volley a ball back and forth across a net, Morgan changed the name of his new game to volley ball (two words). In 1950, the United States Volleyball Association changed the spelling from volley ball to volleyball (one word). This photograph was taken in 1955.

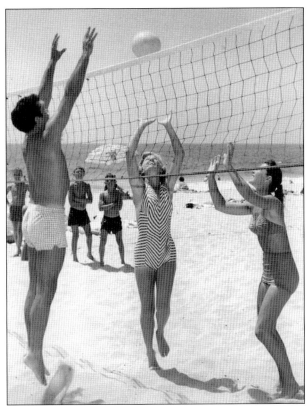

In August 1956, Alex Bolyanatz, coordinator of the Manhattan Beach Recreation Program and chairman of the volleyball division along with Herman R. Brondt, city clerk, and an unidentified gentlemen set up for the first California State Beach Volleyball Six-Man Championship, sanctioned by the Amateur Athletic Union.

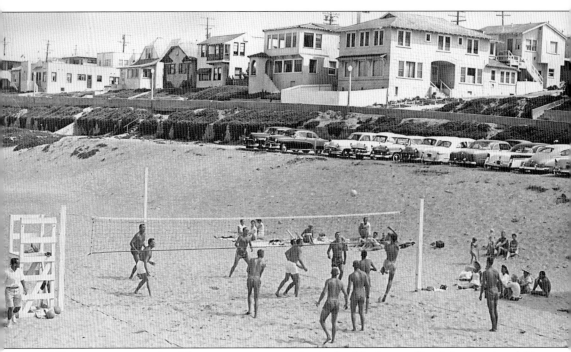

With nets set up north of the pier, participants play in the Manhattan Beach International Six-Man Competition.

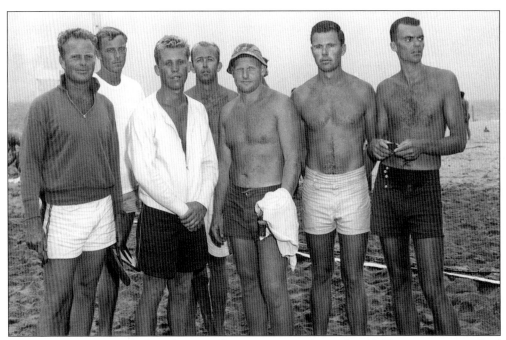

Pictured are some of the players who participated in the 1957 tournament: Bud Waller; Rod Crag; and Jim O'Hara, brother of Mike O'Hara. The rest of the players are unknown.

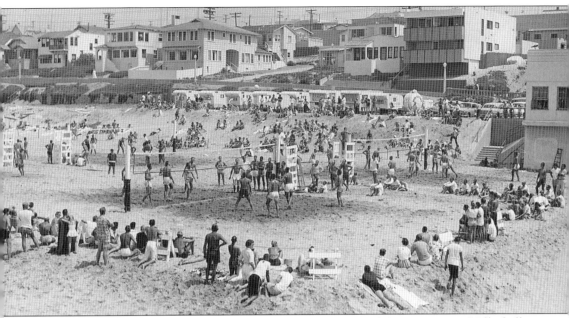

On August 24 and 25, 1957, the men and women's Southern California Summer Volleyball Tournament took place near the Manhattan Beach State Pier.

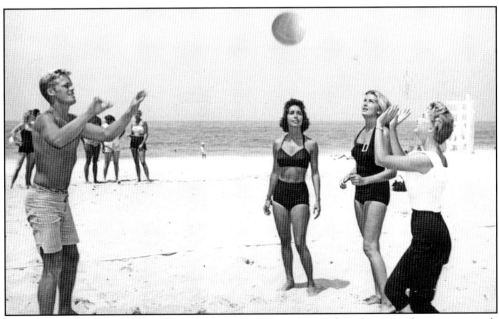

Doug McClure, who played volleyball during the 1950s, is seen here having a fun practice with three lovely ladies during a 1957 tournament. From left to right are Doug's wife at the time (who was from Hawaii), Greta Thyssen (Miss Denmark); and actress Yvonne Lime.

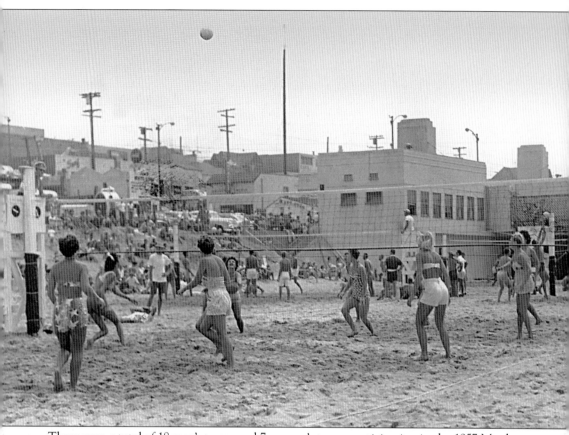

There were a total of 18 men's teams and 7 women's teams participating in the 1957 Manhattan Beach International Six-Man Volleyball Tournament. It was quoted as being one of the best-run tournaments of all time, and $1,500 was spent to assure the court layout and playing facilities would be in excellent shape. Females have been playing volleyball since the early 1900s. With the pier buildings in the background, the Women's Volleyball team pictured here did extremely well in the event. This 1957 tournament drew a notable amount of women to the sport. The first Woman's Open Tournament took place on August 16–17, 1958. The event drew girls from as far away as Mexico City. The Park and Recreation Department of Manhattan Beach, the chamber of commerce and the Southern California Municipal Athletic Association (ASSOC) assumed sponsorship of the first annual championship for beach volleyball tournaments, combining the event along with the International Paddleboard Festival activities.

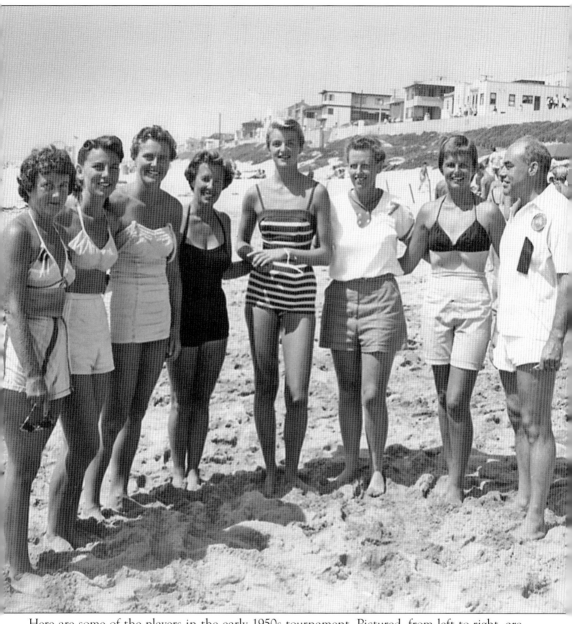

Here are some of the players in the early 1950s tournament. Pictured, from left to right, are Grace LaDuke, Edie Cornrad, Jane Ward, Lila Shanley, Jean Gaertner, Lois Haugerdy, Marion McMahon, and their coach, Al Fish.

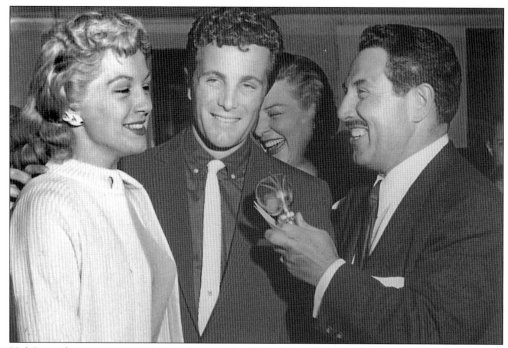

Hal Perry, honorary mayor of Manhattan Beach and popular star of the radio show, *The Great Gildersleeve*, brought many starlets and actors to the chamber of commerce promotional events. Here he introduces Cathy Case and Robert Stack.

At a paddleboard race event, Hal Perry introduces the crowd to Michael Landon, perhaps best known to the nation for his roles in the television series, *Bonanza* and *Little House on the Prairie*. At the time, Landon was promoting his latest film *I Was A Teenage Werewolf*.

Hal Perry introduces starlet Jennifer Holden, noted for her role in the popular 1957 Elvis Presley film, *Jailhouse Rock*. Paul Marsh & Association of Hollywood handled publicity and liaison work for the Hollywood film and television industry.

During the paddleboard races, Bill Thompson, master of ceremonies, introduced Shirley Jones at the chamber of commerce award banquet. The young actress was already recognized for her work in the musical film *Oklahoma*. A later generation would know her best in the television series *The Partridge Family*.

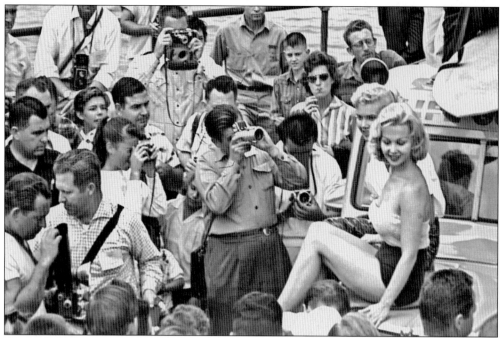

At the 1958 International Paddleboard Race and National Beach Volleyball Championships, another popular event was added—Camera Day. Models and starlets were happy to strike a pose on the pier for the many professional and amateur photographers.

Camera Day was held on Sunday, August 3, 1958 at the Lions Clubs International building on the pier. Robert M. Smith (left) was chairman of the steering committee of the colorful weekend.

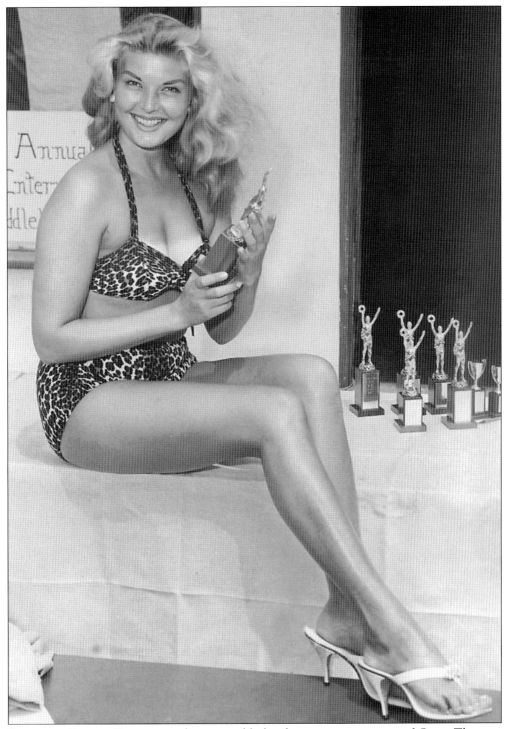

For many, Camera Day was made memorable by the guest appearance of Greta Thyssen, Miss Denmark.

In 1960, six-year-old Robin Curtis reigned as Miss Paddleboard of the International Paddleboard Race. This competition coursed from the Isthmus of Catalina Island to the Manhattan Beach Municipal Pier, now referred to as the Manhattan Beach State Pier. Her youthful image was a delightful contrast to the pageant beauties of past events.

Screen actor and stunt man Jock Mahoney served as the grand marshal for the International Paddleboard Festival Parade in 1960. That year the event was billed as the biggest water sport event staged in the South Bay—bigger in size and number of activities than all previous years.

On the sand, with the pier in the background, Miss County Recreation of 1960 stands with Tom Zahn, one of the 18 athletes entering the paddleboard race. Working as a lifeguard in Newport Beach, Tom was recognized as the dean or "old man" of paddle boarding at age 35. Zahn explained simply, "The only reason I keep up is because I keep in shape and have the experience."

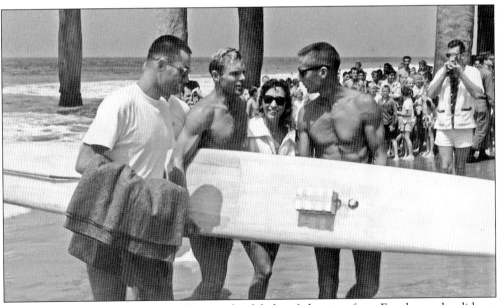

A four-time winner, Zahn came ashore to the delight of cheering fans. For those who did not make the 32-mile crossing, escort boats began pulling the poorly trained entrants out of the water at about the five-mile mark.

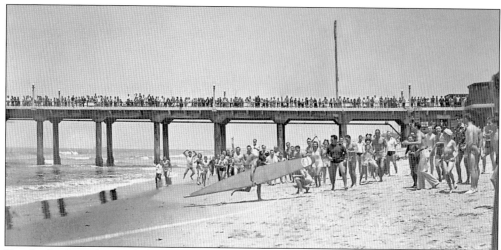

Hundreds of people crowded the pier and beach to watch the finishing entrants come ashore. For the first time, the 1960 race saw a woman in the competition. Violet Velenzuela, who resided at 309 South Poinsettia Avenue, was the mother of five and an employee of the Bank of America in Manhattan Beach.

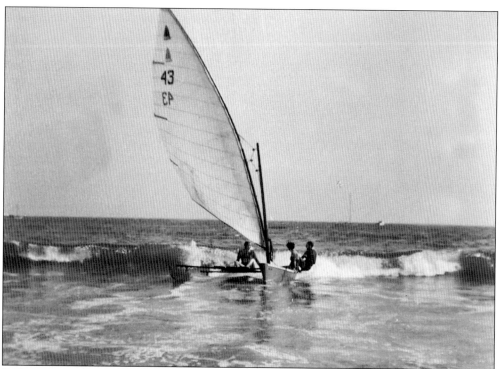

Sailing was another popular event of the festival. Six sailboat races (of different classes) attracted more than 100 boat owners to sign up for the weekend event. Approximately 40 catamarans participated in the race that began at the Manhattan Beach State Pier, went to the beaches of Santa Monica, and came back to the pier.

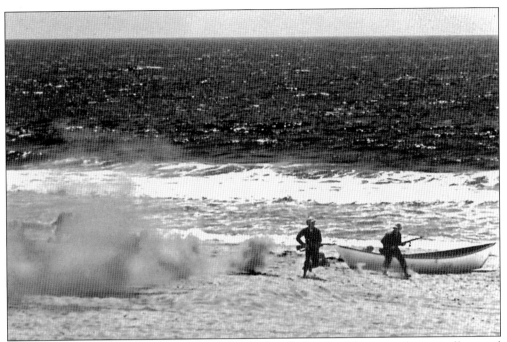

On the last day of the festival, the Marines hit the beach. South of the pier, a dramatically staged demonstration called the "Reduction of Fortified Position" was performed by the U.S. Marine Corps of Santa Monica.

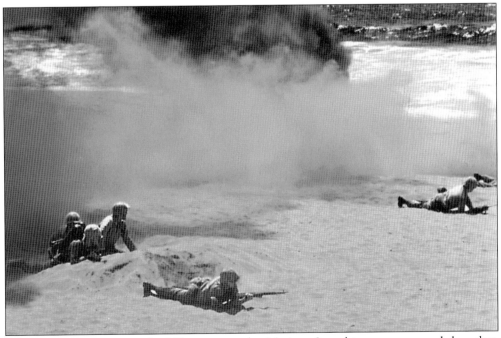

The military maneuver involved 30 reserve combat Marines, 2 machine guns, a grenade launcher, rifles, a flamethrower, and the installation of an "enemy" pillbox. Some 1,000 spectators watched the exercise from bleachers set up on the beach.

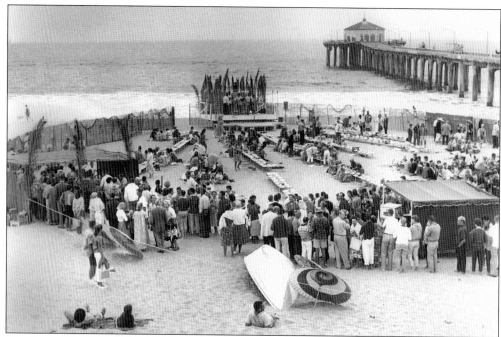

The International Paddleboard Race of 1960 was to be the end of the annual event begun in 1955. The event had been suggested by county lifeguard Bob Hogan with the Manhattan Beach Chamber of Commerce as a cosponsor. One of the features of the festival was the Malo Taa Loo. Attracting hundreds of people, its winners were awarded trophies for volleyball, dory, and paddleboard races.

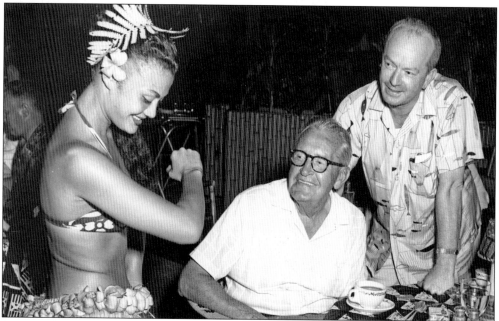

Reri of Tahiti dances for two appreciative audience members at the Queen's Surf in Hawaii. Clif Webster, seated, and Bob Jean went to the island from Manhattan Beach to stir up interest in their city's annual paddleboard race from Catalina Island to Manhattan Beach.

Six

Then Came Change

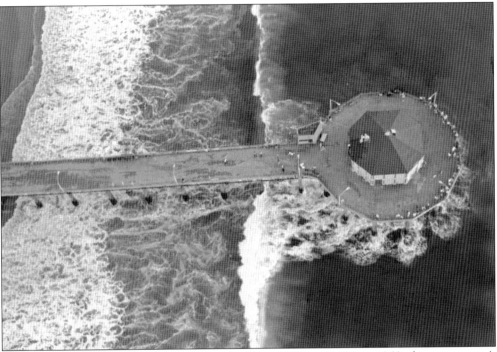

As the population growth increased from 19,330 in 1950 to 33,934 in 1960, the community's interest in maintenance and preservation of the pier and surrounding beach area increased. In 1957, the city council approved the deed transfer of the pier to the state for the sum of $1 along with the ability to retain mineral and oil rights. The Los Angeles County assumed maintenance of the pier with conditions—no night usage, closed during storms, and no cars on the pier. It was clear there was maintenance to be done. Subsequently, major remedial work, including extensive shotcreting of the piling and superstructure was proposed. In 1959, city manager Gayle T. Martin, who had been appointed to the position in 1956, announced that the state approved renovations and would appropriate $305,000 to rehabilitate the pier. With all this work being centered on the pier, other beach activities continued with great excitement and energy through the 1960s. In 1963, the First International Surf Festival Paddleboard Race was held. In 1968, the Sixth Annual International Surf Festival was held having been jointly proclaimed by three mayors—Al Valdes of Hermosa Beach, William F. Cuzuliger of Redondo Beach, and Russell C. Nicholson of Manhattan Beach. It was felt the unified effort would bring international fame to the South Bay Beach area.

This photograph captures a view of the pier at the end of Manhattan Beach Boulevard before the storm. The area, and its plentiful restaurants, has always been a place of many activities for both sightseers and beachgoers to enjoy.

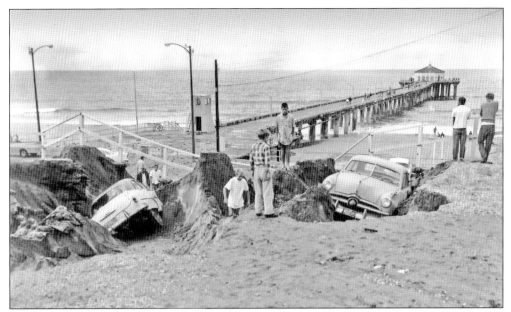

It was not only the pier that received damage from winter storms. In February 1962, curious sightseers examined the damage caused by a storm of a cave-in of the parking lots situated above The Strand immediately east of the pier.

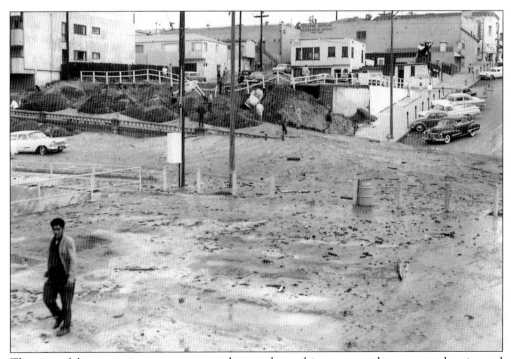

The powerful wave action was so strong that sand was driven across the entry to the pier and onto the bike path and Strand. The man seen in the lower left was walking on the sand and debris-covered pier entry.

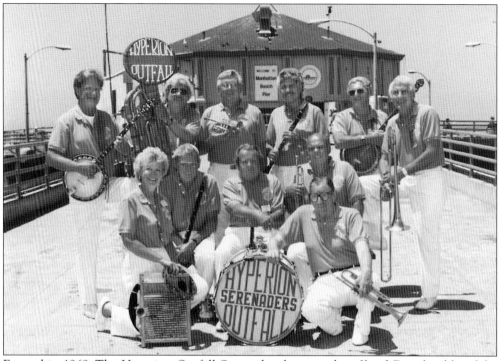

Formed in 1969, The Hyperion Outfall Serenaders became the official Dixieland band for Manhattan Beach by a city council proclamation in 1975. The group played at most of the functions held there.

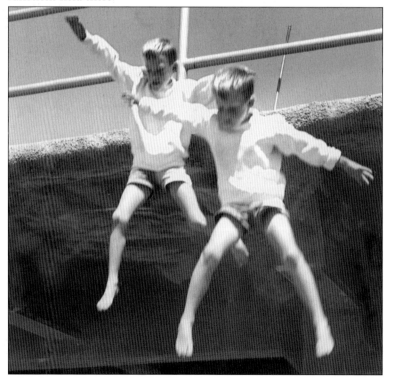

Boys will be boys! In May 1963, Andy and Tom Downs (ages six and eight) thought it would be great fun to jump from the Manhattan Beach Municipal Pier. It was and is today an unlawful activity. Fortunately, the boys had a soft landing. However, for some, plunging off the pier has resulted in injuries and in several instances, death.

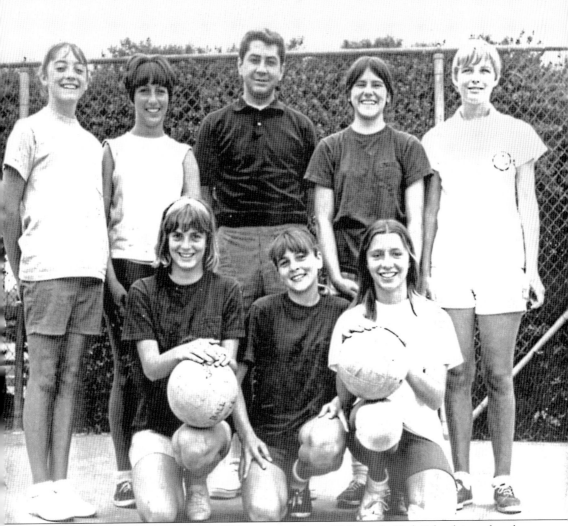

In 1966, Charlie Saikley, a young Special Education teacher at El Segundo High School, introduced a new venue to the activities held at pier side. Working summers with the City of Manhattan Beach since 1963, Charlie started the first "Girls Volleyball" team in 1965. Practice took place at Live Oak Park, which at that time provided a sand area now used as the park's Tot Lot for children. Pictured here, from left to right, are (first row) Donna Black, Chris Rogers, and Jill Taylor; (second row) Joyce Bersford, Val Croze, Charlie Saikley, Debbie Malpee, and unidentified.

With the pier in the background, the young women soon had tournaments of their own. They were unique in the display of the names of their team (the Tyros) imprinted on the back of their swimwear and T-shirts. In addition to the Tyros team, Charlie coached the 11- to 13-year-old team called the Pacers. After moving their practice venue down to the pier, Charlie saw the practical need to lower the volleyball net height. Prior to 1970, Manhattan Beach had the only courts set in this manner.

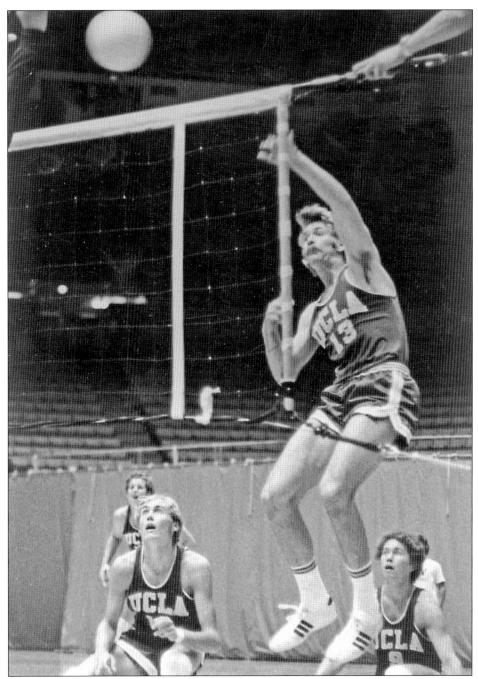

Along with the sporting talents of the young women playing volleyball, the Manhattan Beach Pier drew one of the greatest athletes in the history of the South Bay. Kirk Kilgour, a volleyball legend, started playing the game near the pier. By 1967, at the age of 19, he held an AA rating for Men's Beach Volleyball and an AAA rating in 1968. In 1970–1971, he began playing indoors on UCLA's first championship volleyball team. His volleyball uniform became the first uniform to be retired. His name appears in the Helms Athletic Hall of Fame as well as the California Beach Volleyball Hall of Fame. In 2002 at the age of 54, he succombed to heart failure.

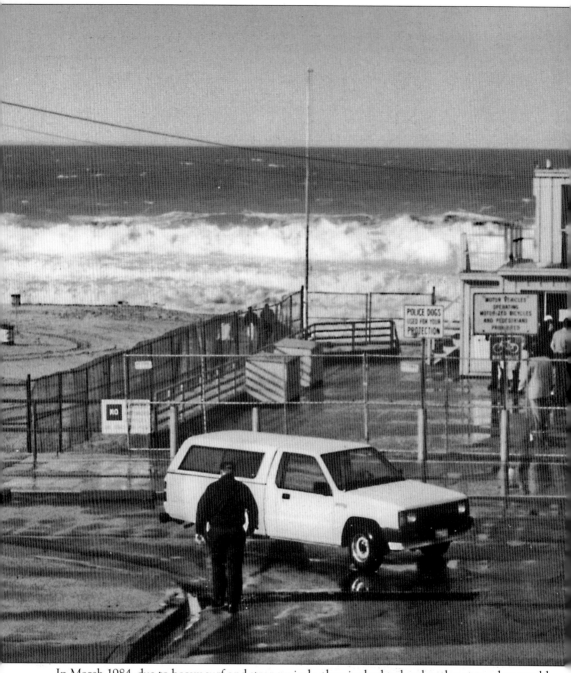

In March 1984, due to heavy surf and strong winds, the pier had to be closed, a scene that would

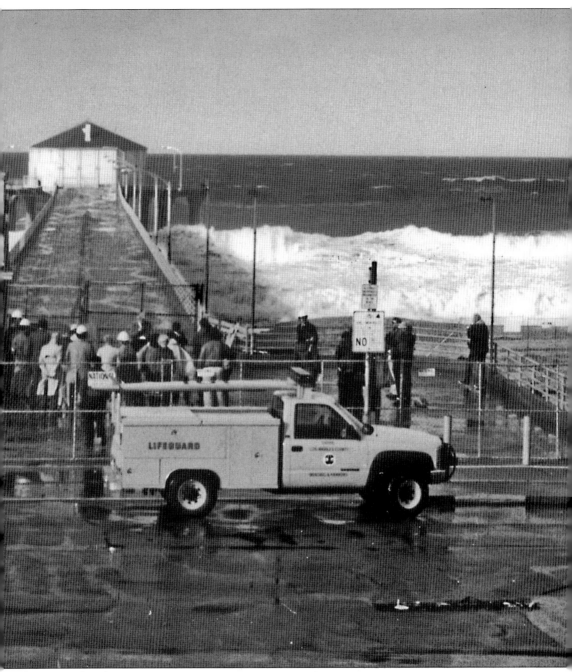

be repeated in future years.

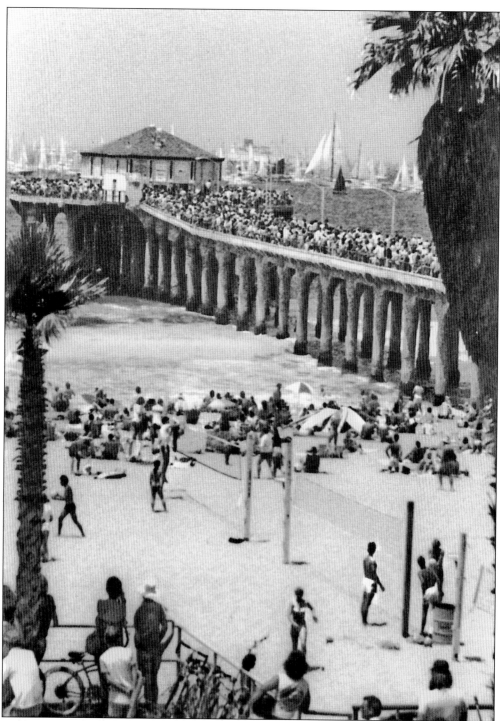

On July 4, 1984, with calm seas, thousands of visitors and residents crowded the pier as well as beach to catch a glimpse of the Olympic Tall Ship Parade of Sail celebrating the Los Angeles Olympic Arts Festival and summer Olympic Games. A cannon shot at high noon signaled the beginning of the parade. The stately ships came from several countries around the Pacific.

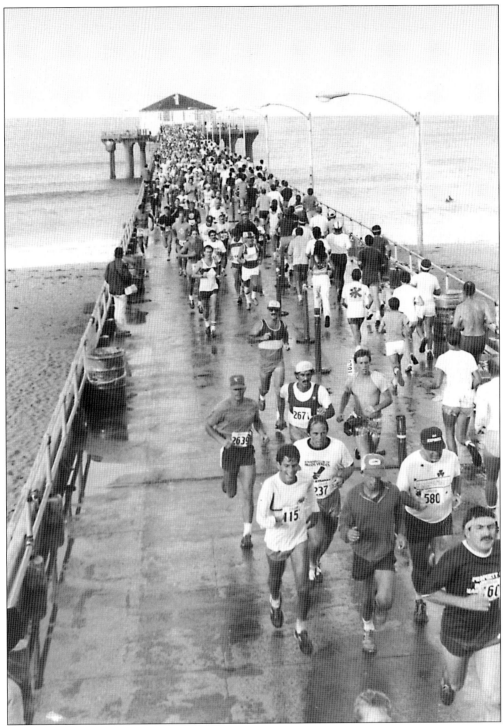

Since 1977, each year in early October, the Manhattan Beach 10-Kilometer Run has taken place. Originally the course incorporated a stretch down the pier. Although that stretch has been eliminated due to safety factors, the race continues along with the October Home Town Fair.

In 1977, the Fruin family posed for this photograph in front of the Roundhouse at the end of the Manhattan Beach Pier in 1977. From left to right, they are Dr. Richard Fruin, Gertrude Fruin, Judge Richard Fruin, Irene Eide, Thomas Eide Fruin, R. Mathew Fruin, and Patricia Fruin. In 1979, Judge Richard L. Fruin established the Oceanographic Teaching Stations, Inc. (OTS) and incorporated the station as a non-profit corporation in 1980. The OTS operates the Roundhouse Marine Studies Lab and Aquarium, which occupies part of the familiar structure located at the end of the city pier. The OTS is governed by a board of seven directors, and employs three full-time and three part-time staff members. The purposes of the organization are to foster and promote the public study of and interest in the oceans, tidelands, and beaches of Southern California as well as the marine life therein and the impact of human population on the environment. OTS continues to provide a unique marine experience and quality education to thousands of visitors and students of the South Bay, Los Angeles, and surrounding areas.

Through its dynamic educational programs, OTS has developed community and regional awareness, involvement, and support for the diverse oceanic environment. In 1985, the organization received the Community Commendation Award from the chamber of commerce for their outstanding work with the youth of the area. Pictured, from left to right, are E. Hannah, unidentified, C. Marsh, and F. Armstead.

In 1985, the OTS display area within the Roundhouse looked much different than it does today. However, the educational facility has continued to bring in exhibits appealing to all ages.

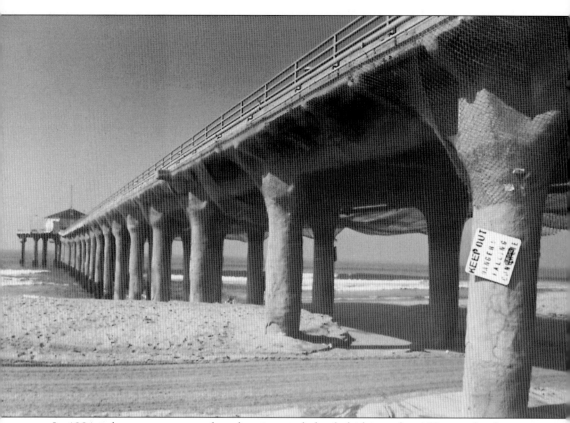

In 1984, it became apparent that the pier needed refurbishing after 150 pounds of concrete fell on a jogger, paralyzing him. Signs reading "Keep Out—Danger of Falling Concrete" were prominently posted. A chain-link fence was installed covering most of the underside of the pier to catch falling debris. Due to the accident, the city, county, and state were sued. The county approved a record personal injury settlement of $3.26 million to victim George Benda, after a two-year lawsuit. In 1986, it was time for Los Angeles County to rid itself of its biggest potential liability by returning the operation and maintenance of the Manhattan Beach Pier to the state. County supervisors voted 1-4 that the state would be responsible for full liability of the corroding pier. There were heated discussions regarding allowing for a restaurant or simply replacing the existing structure. There was strong opposition from many residents after a rumor indicated that the city had met with the county and entered into a preliminary negotiation to either allow for a restaurant on the pier or replace the existing pier. It was ultimately decided that the original pier would be reworked and that there would be no restaurant on the pier. By November 1988, the City of Manhattan Beach agreed to a $2 million facelift for the crumbling pier. Although owned by the state, the structure has been operated and maintained by the Los Angeles County Department of Beaches and Harbors under conditions set by a 25-year county-state contract after the City of Manhattan Beach sold it to the state in 1956 for $1. However, the state retains the option to restore or replace the historic landmark.

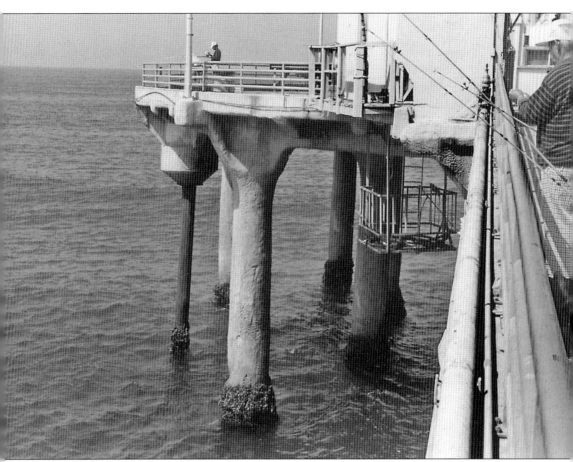

In 1984, the County Engineering Dive Team performed an in-depth underwater inspection of the piling. There had been reports that the pier was plagued by cracked and falling concrete with rusting exposed girders. Even some of the lampposts were being held together with wire. Most of the piles exhibited extensive marine growth; vertical cracking above the water line on several and telltale rust stains adjacent to the cracks. The year 1985 became known as the "Year of the Pier." There was genuine fear for the future of the pier since the engineers report stated it may be more cost effective to tear down the pier and build a new one. To bring attention to the plight of the structure, a campaign called "Pier Pressure" was formed, spearheaded by Keith Robinson and Julia Tedesco. It was their conviction that the pier was an historic symbol of the city.

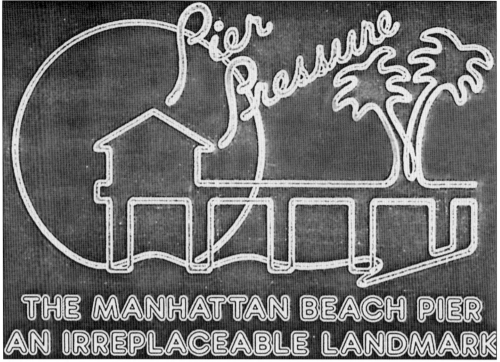

Pictured is the logo of the "Pier Pressure" organization. It was their hope they could prevent the pier from being replaced.

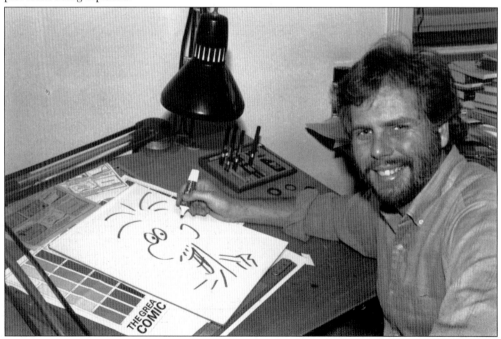

Keith Robinson, a cartoonist, designed the logo for the group and, with the help of Julia Tedesco, then president of the historical society, went to work gathering support to save the pier. They lobbied the state, county, and city.

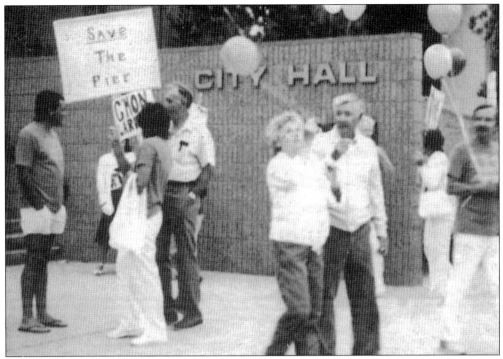

In September 1986, while discussions were going on in the Manhattan Beach Council chambers, supporters of restoration staged a demonstration outside. By a three to two vote, the city's recommendation to the California Department of Parks and Recreation was to restore the pier rather than to build a new one.

In 1986, the county did replace the handrails, curbs, and drinking fountains as well as repairing the bait stations. The state replaced some of the benches.

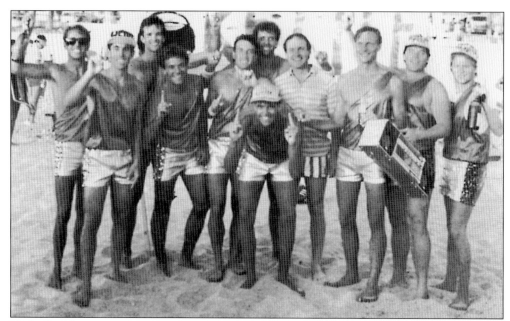

With all of the commotion regarding the future of the pier, there was no slack in beach activities. The volleyball "Kettle Team" won the 1985 Surf Festival Championship. A first was their appearance during the Manhattan Beach Six-Man/Six-Woman Open in satin trunks and using their own sound system. Pictured, from left to right, are Matt Dodd, Kevin Cleary, Joel Jones, Chris Carico, Greg Fontana, Tedd Dodd, Brent Frohoff, Tom Simms, Chris Warshaw, Robb Stroyke, and R. K. Nyman.

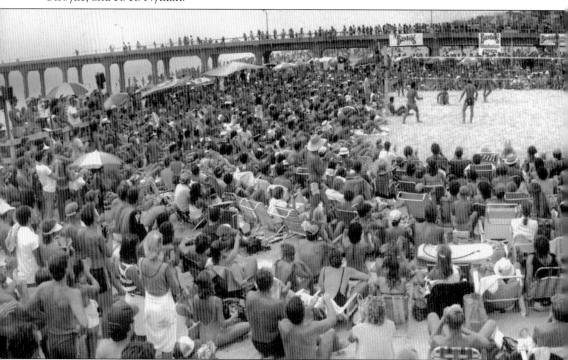

On August 9 and 10, 1986, the 27th Manhattan Beach Open Tournament took place. Seen above

Tim Hovland (left) and Mike Dodd played as a team for several years, and became four-year defending champions by 1986. Highly accomplished in the sport of volleyball, both in this country as well as the European League, Hovland looked forward to the summer volleyball open contest in Manhattan Beach. And the Manhattan Open was Dodd's home turf. A typical "home town boy," Mike Dodd graduated from local Mira Costa High School. In 1979–1980, he was middle blocker for San Diego State University.

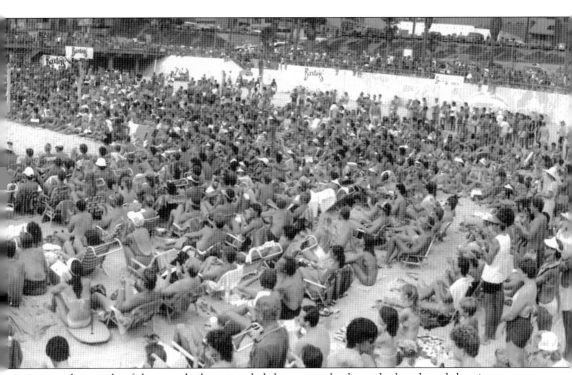

is a good example of the crowds that attended the events, both on the beach and the pier.

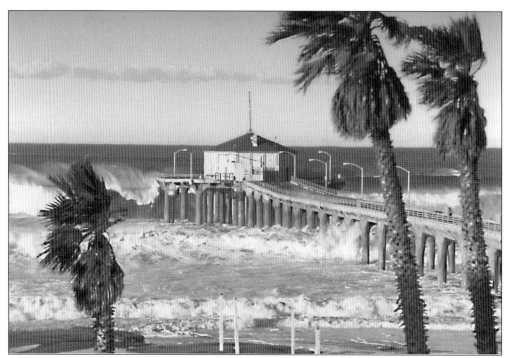

January 1988 saw one of the most fearsome winter storms to ever hit the coast. Giant breakers were crashing on the deck of the pier along with waves reaching the railing surrounding the Roundhouse. It was necessary to close the pier for safety.

Sand and debris were liberally deposited about the base of the pier as the waves relentlessly washed over the beach sucking out the volleyball courts. It was estimated that it would take years to replace the eroded sand.

Seven

AN ICON REBORN

It took years of planning and tireless hours by many residents and city, county, and state personnel to come to an agreement on the designs for the rehabilitation of the pier. On January 23, 1989, the Manhattan Beach Pier and adjacent parking lots became the maintenance and operational responsibility of the City of Manhattan Beach for the first time since 1957. However, it would not be until January 15, 1991, for the city council to award a contract of $2.39 million to the Kiewit Pacific Company for the first phase of the project. The second phase of work, which consisted of the Roundhouse and comfort station rehabilitation, was contracted to Kevin Krauss Construction. The third phase was the replacement of the lifeguard station that would remain the same size; however, the building would be moved to the north side of the platform. Michael Daly, spokesman for the city, outlined the process of restoring the historical landmark and the proposed timetable needed to achieve each phase of the project. The object of the restoration was to retain the original style of the pier, Roundhouse, and light standards.

In 1991, city manager Bill Smith, who had been on the job for only a short time, was soon in the center of the pier renovation. The project was at the forefront of the city's agenda. Smith was fortunate to have knowledgeable staff member Michael Daly. Daly had been involved with the project from the beginning when the Pier Pressure group was fighting for restoration rather than new construction.

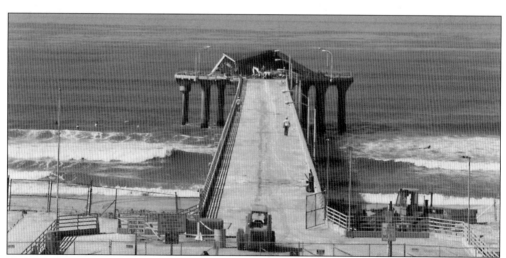

On March 1, 1991, at 8 a.m., the restoration began with a pier breaking ceremony, signaling the commencement of the project. The Roundhouse, bait shack, and lifeguard tower were the first structures to go. Not since 1922 had anyone seen the end of the pier without the familiar building.

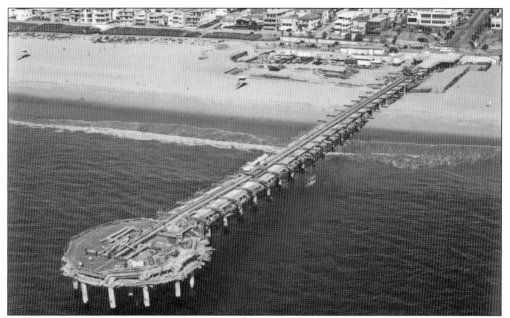

Pictured here is an aerial view of the pier construction. Most of the pier was demolished in March 1991, clearing the way for the removal of the pier's deck. On February 12, the contractor had set up a construction yard (top center) on sand to the north side of the pier.

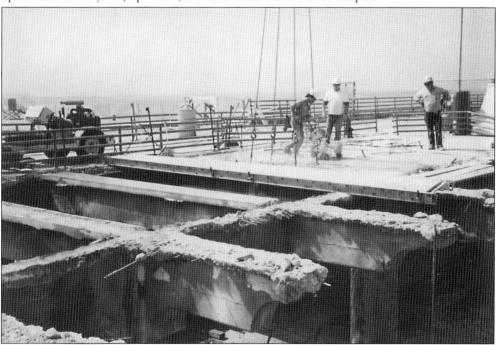

The load capacity of the pier deck would not allow the contractor to use heavy equipment thus requiring the use of a smaller bulldozer for the demolition and removal of the debris. Exploratory holes were drilled into the deck to determine the exact location of the beams and girders in order to avoid accidentally cutting into the beams. By the end of March, the crew of Kiewit Pacific began the cutting and removal of the historic deck.

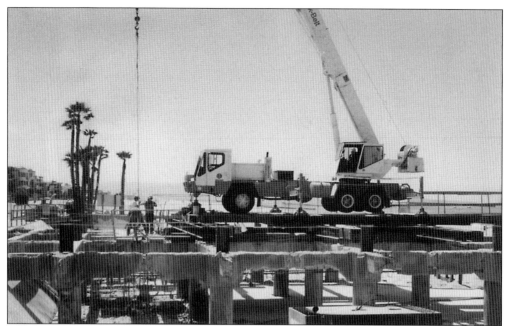

In order for a crane to be driven up on the piles, a wooden mat was laid down creating a stable platform for the removal of the old concrete deck. The crane remained on the pier until new concrete was poured.

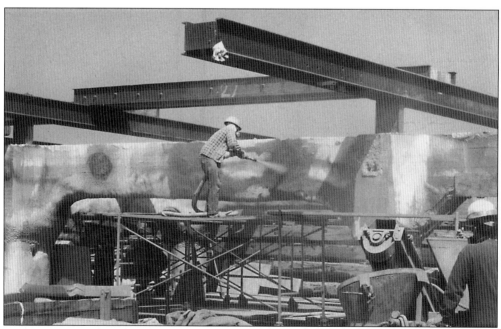

Concrete work began at the end of April 1991, and was complete in October. The concrete was loaded from trucks into a large concrete pump, which propelled the mixture over the surface of the pier, a process known as shotcreting. The poured concrete area extended from the edge of the bike path to the old lifeguard station platform. It took many more pours before the full length of the pier was completed.

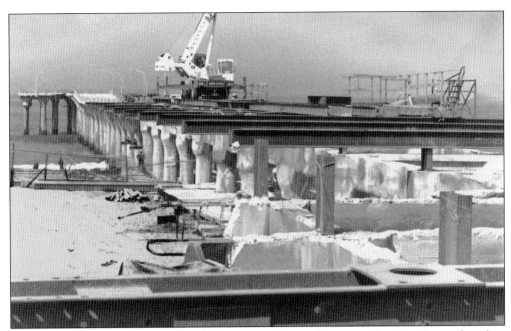

As the demolition phase proceeded over water, lifeguards restricted swimming and surfing adjacent to the pier. A 50-foot safety zone was marked on both sides of the pier prohibiting any water activity.

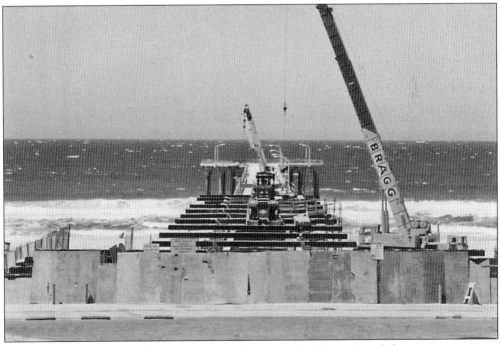

As work went on, a plywood fence was erected between the bike path and the new construction as a safety barrier for both bicyclists and pedestrians.

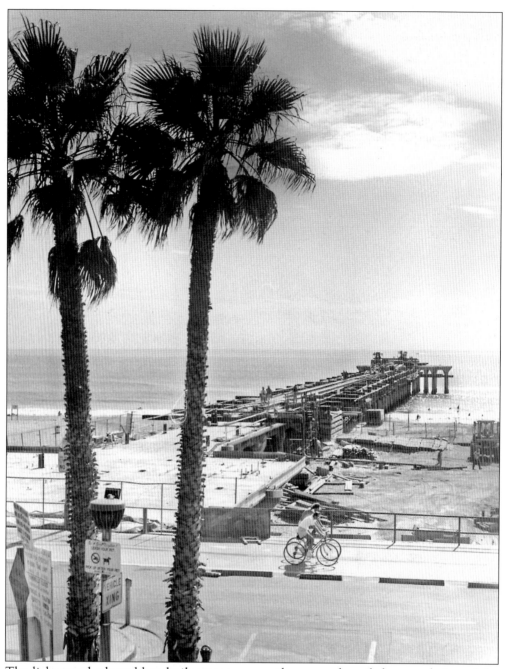

The light standards and handrails were temporarily removed until the completion of the rehabilitation at which time they were returned.

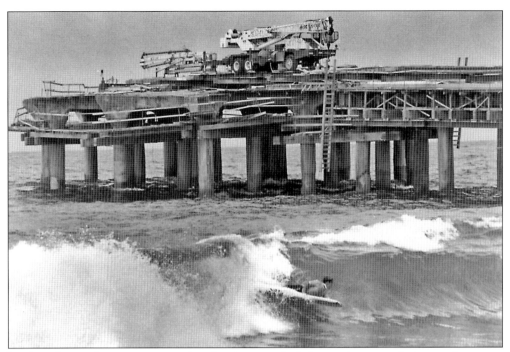

In this photo, the concrete pouring for the new deck is nearing completion as the crane reaches the end of the pier. When finished, trucks will then be able to begin construction on the Roundhouse.

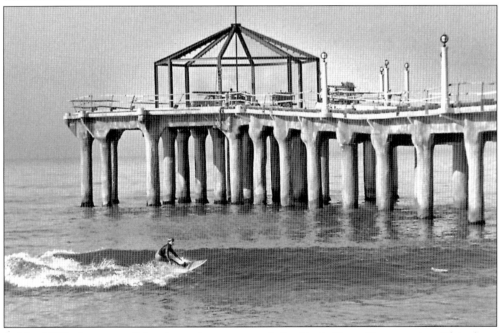

In May 1992, phase two of the pier project was awarded to Kevin Kraus Construction. This phase included the rebuilding of the Roundhouse and the renovation of the comfort station restrooms located north of the pier entry. Whatever the phase, surfers and jet skiers were not disturbed and continued their enjoyment of riding the waves.

After careful inspection of the Roundhouse's progress, it was decided that the snack shop, previously located outside the Roundhouse, would be better incorporated within the design of the structure.

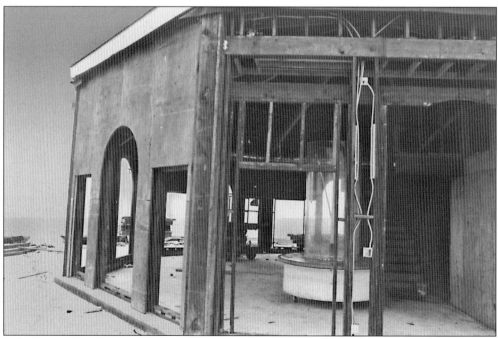

When finished, the rebuilt landmark featured a red tile roof, French windows, and a copper cupola topped with a weather vane as well as roll down shutters to discourage vandalism. The new building was modeled after the original one as it appeared in 1920.

This shows one of many display tanks that was to be used for the new oceanographic training station and marine lab.

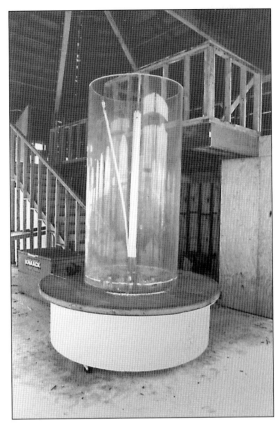

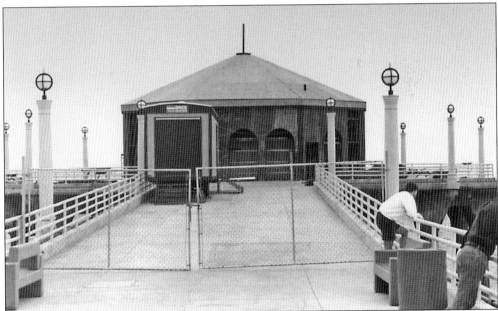

During the Roundhouse rebuilding, the marine lab was relocated to a site on the beach in El Segundo, a neighboring town to the north. After a year of rejuvenation, the pier reopened in early March; however, the Roundhouse would not open to the public until July 1992.

July 18, 1992, was a proud day with a festive atmosphere as representatives of the city council and honorary dignitaries walked down the length of the pier to the new Roundhouse Pavilion. At the grand opening, a new flagpole was dedicated; it was donated by the "Pier Pressure" group that had been formed by the historical society.

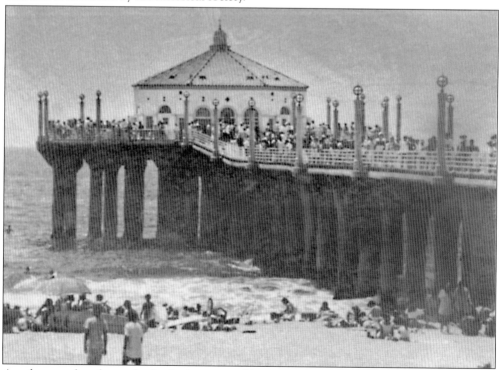

As thousands of people looked on, a ribbon cutting ceremony was held to open the Roundhouse.

Crowds of residents and guests filled the pier and beach, all taking part in the dedication ceremony. This day marked the conclusion of the pier's rejuvenation and restoration project. Construction had begun in February 1991, and ended 17 months later, finishing ahead of schedule.

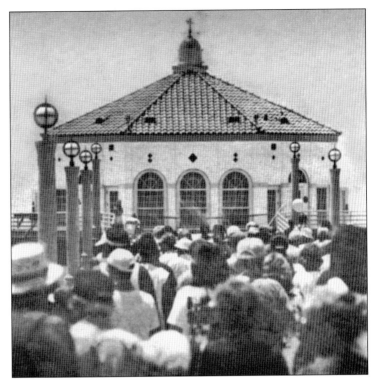

The Hyperion Outfall Serenaders performed to the delight of the crowd.

This 1998 photograph displays the many changes made to the pier and its buildings. The lifeguard station was originally built on the left side of the pier base. Due to its popularity with swimmers, the right side was chosen over the south side, a site largely preferred by surfers.

It can be noted that the roof of the lifeguard tower was designed to blend in with the architectural style of the Roundhouse. The station was built on the right side of the pier's base with all overhead utility wires now placed underground.

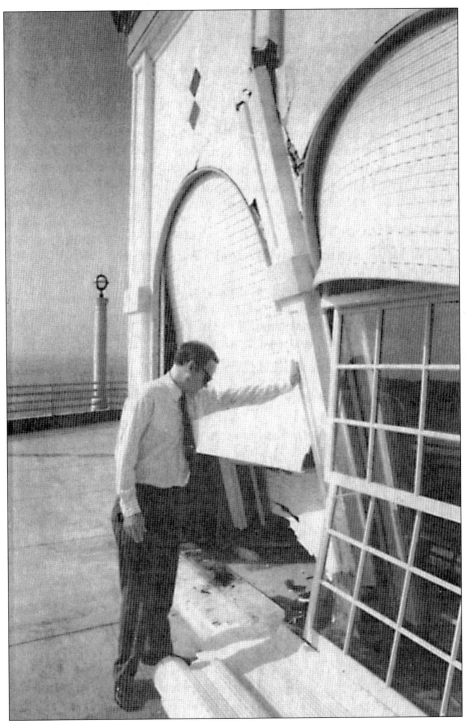

It was less than a month from the grand opening of the Roundhouse Museum, located at the end of the pier, when a fleeing driver in a car traveling 90 miles per hour hit the new structure. Police captain Robert Cashion surveys the damage caused by the crash. Damages were estimated at about $30,000.

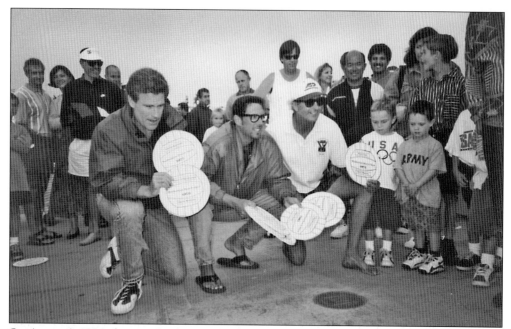

On August 8, 1996, the completely renovated pier added a new attraction, the Manhattan Beach Pier Volleyball Walk of Fame. Inlaid on the deck, bronze plaques assured local Manhattan Open volleyball players lasting recognition for years to come. Appearing here are such greats as Chris Marlowe, Mike Dodd (1996 Olympic silver medalist), and Matt Gage as they display paper replicas of the plaques while volleyball fans celebrate the event.

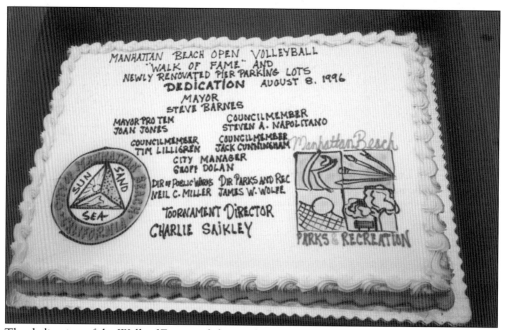

The dedication of the Walk of Fame and the newly renovated pier parking lots was a sign of civic pride and allegiance to the game of volleyball.

Eight

She Stood Her Ground

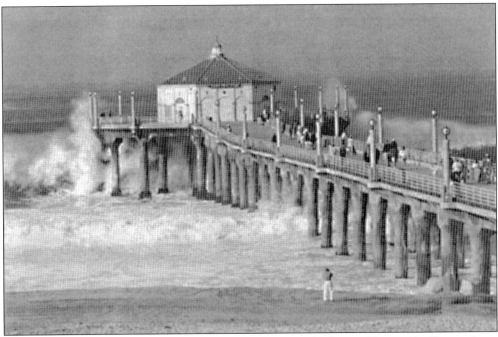

As a new decade began, the historic Manhattan Beach Pier had a notable record of having been battered by the elements from the beginning. Periodically there had been great damage, but with all the work done in the 1990s, there was little fear the pier would be unable to sustain all future storms that Mother Nature might send her way. However, by July 2000, the city found itself at the disposition of Los Angeles Superior Court Judge Cary Nishimoto. In 1999, due to numerous cracks found in the pier light standards, which had been reinstalled in 1992 as part of the pier's reconstruction, the city wanted them replaced. The problem was brought to the city's critical attention in 1998, when a strong windstorm caused one of the light poles to blow down. The situation was resolved with the city getting new light standards. Having survived as the city's icon for close to 100 years she has been silent witness to significant events such as the beach sport of sand volleyball, now an international Olympic event. Developing as it did through the years into the Manhattan Volleyball Open with its all-time highs in attendance and by the steadfast work of Charlie Saikley (honored by election into the California Beach Volleyball Association Hall of Fame), it, too, becomes a lasting symbol of this unique seaside community.

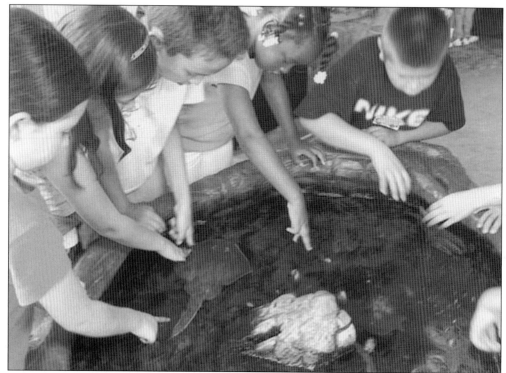

The Roundhouse Marine Studies Lab and Aquarium is a favorite field trip for many children. The variety of "hands-on" activities include the touching of sea creatures and operating ocean themed computer programs. The Roundhouse is open to the public and admission is free.

Many fund-raisers and receptions were held for the benefit of the OTS Roundhouse Lab and Aquarium. One such event was a reception given in June 2000, attended by approximately 100 people. The attendees were honored by the presence of Jean-Michael Cousteau, son of the late Jacques Cousteau, pictured here with Kecia Tessler, then director of the Roundhouse.

The Manhattan Beach Pier has been portrayed in many different ways—from paintings to photographs. Victoria A. Dennis needed a historical landmark for a school project, and having visited the Manhattan Beach Municipal Pier on many occasions, she chose to make a model for her assignment. Like many young visitors her experiences and enthusiasm are reflected in her efforts shown here.

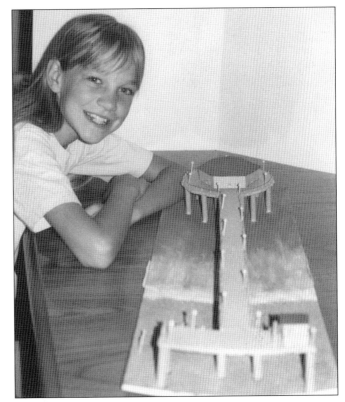

The model is constructed of cardboard with beads used for the light standards. Red corrugated paper serves as the tiled roof. The angle of the photograph replicates what one might see standing at water's edge on the north side of the pier.

In early 2002, donations made possible the purchase of a 3,500-gallon fiberglass tank. Unloaded at the Roundhouse Aquarium, it would serve as housing for local species of sharks such as Leopard, Horn, and Swell. The installation of the new tank marked the first phase of a major renovation of the aquarium.

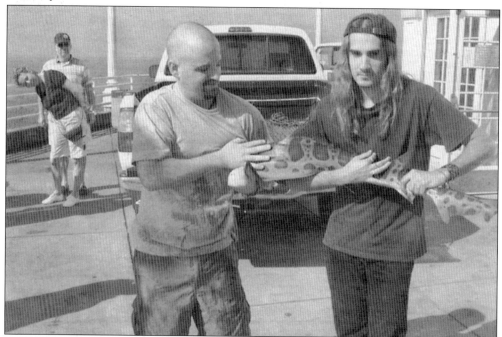

Renovation resulted in the second closing of the Roundhouse Aquarium in two years. Some of the current marine species were released back into the water while others were transported to outdoor tanks at the Redondo Beach Marine Lab. Employees Jose Bacallao and Tony Taymourian are photographed just prior to releasing the Leopard shark back into the ocean.

Charlie Saikley could be called the father of the Manhattan Open. Saikley's early passion was basketball, which he coached in El Segundo before joining the Manhattan Beach Recreation Department where the passion became volleyball. In 1964, Charlie began running the volleyball tournaments down on the sand, south of the pier. Dedicated to the success of the game, he valued the importance of detail. As an example, he insisted the courts be watered down for eight hours a day five days prior to a tournament, making the sand as hard packed as possible. Another "must" was carefully dragging the courts to a perfect level. In April 1997, Charlie Saikley was inducted into the California Beach Volleyball Hall of Fame. For many spectators and players alike, the Manhattan Open, a six-man volleyball tournament, has become the "Wimbledon of Beach Volleyball." In 2003, Charlie Saikley received a plaque from the city for his 40 years of dedication and service to the event.

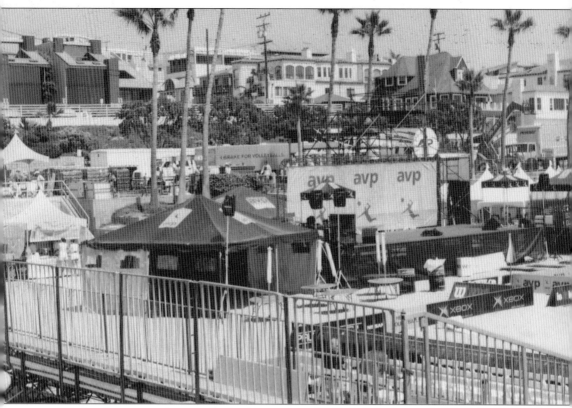

The beach area was the stage for the Association of Volleyball Professionals (AVP) 2002 Michelob Light Manhattan Beach Open held from August 8 to August 11. The main court was surrounded

Installation of the now legendary Manhattan Open tournament brought spectators of all ages. Jacob Jelmini, a local resident and volleyball enthusiast, watched with anticipation. Bleacher seats accommodating 4,500 people were set up for the convenience of the thousands of cheering fans attending the games.

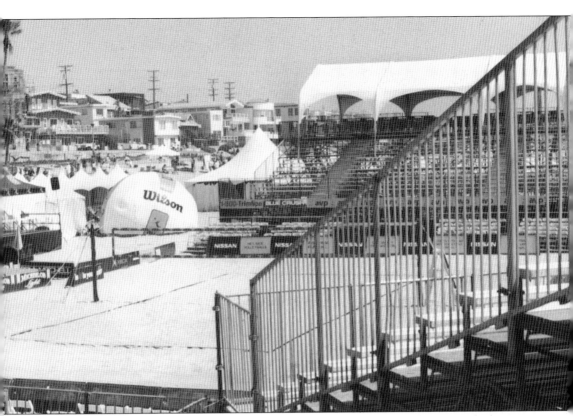

by AVP Fan Parties, and special activities such as the men's and women's qualifiers, youth clinics, and youth tournaments.

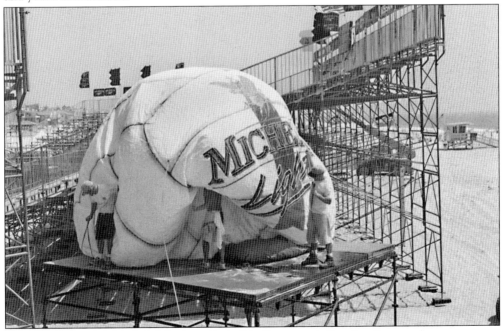

This larger-than-life Michelob Light volleyball balloon was inflated to fly over the games.

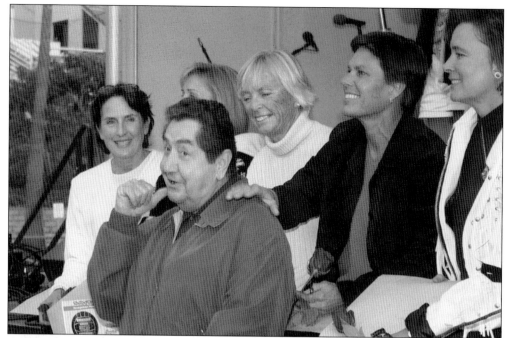

Nina Grouwinket Matthies gives Charlie Saikley a pat on the back for his long commitment to women's beach volleyball during the inauguration ceremony for the Women's Volleyball Walk of Fame (December 2004). On the left is Georjean Garvey, daughter of Jean Brunicardi, winner of the first Manhattan volleyball tournament for women in 1966, called the "John Show Open." Christy Hahn (white turtleneck) and Karolyn Kirby (far right) are both well-respected volleyball players. Altogether there were 37 two-woman teams honored for winning in Women's Manhattan Open Volleyball tournaments.

Kerri Walsh (and her partner Misty May) received a gold medal for beach volleyball at the 2004 summer Olympic games in Athens, Greece. They are among the many deserving women players. Kerri's name now resides on one of the prized plaques of the pier's Walk of Fame.

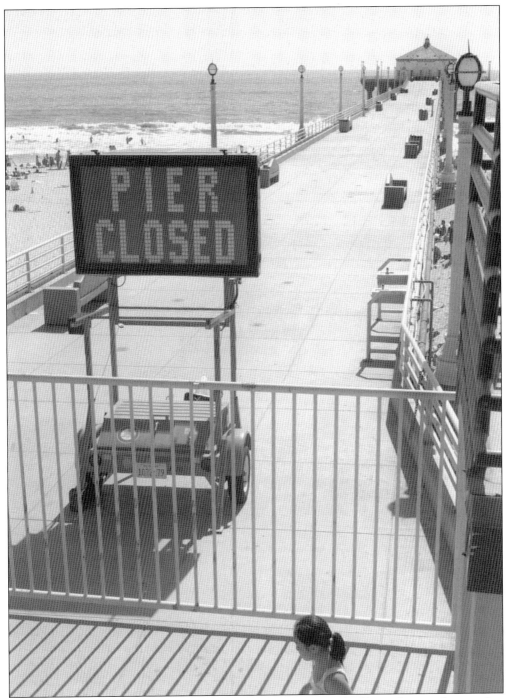

In May 2004, a "Pier Closed" sign was posted at the entrance as had been done in the past, but not because of construction or storm damage; the closing was due to "killer bees." A swarm numbering 30,000 to 40,000 bees invaded the pier area, and for two days, access was forbidden until a beekeeper was able to clear out the marauders and the pier declared safe again.

There may have been storms, disagreements, conflicts, and oppositions to its development over the last 100 years, but all paths eventually led to the historic Manhattan Beach Municipal Pier—a city's icon.